IMAGES
of America

THE LAND OF RIDGE AND VALLEY

A PHOTOGRAPHIC HISTORY OF THE NORTHWEST GEORGIA MOUNTAINS

IMAGES
of America

THE LAND OF RIDGE AND VALLEY
A PHOTOGRAPHIC HISTORY OF THE NORTHWEST GEORGIA MOUNTAINS

Donald E. Davis

ARCADIA
PUBLISHING

Published by Arcadia Publishing
Charleston SC, Chicago IL, Portsmouth NH, San Francisco CA

Library of Congress Catalog Card Number: 00-107277

For all general information contact Arcadia Publishing at:
Telephone 843-853-2070
Fax 843-853-0044
E-Mail sales@arcadiapublishing.com
For customer service and orders:
Toll-Free 1-888-313-2665

Visit us on the Internet at www.arcadiapublishing.com

CONTENTS

INTRODUCTION

Unique to the South are the northwest Georgia mountains. Known by geographers as the "Armuchee Ridges," these picturesque mountains are part of the Ridge and Valley physiographic province of the southern Appalachians. Taylors Ridge, Johns Mountain, and Rocky Face comprise a significant portion of the mountain region, although numerous smaller ridges are considered part of the geographic area as well. Popular recreation areas such as Lake Marvin, The Pocket, and Redwine Cove are found within the boundaries of the northwest Georgia mountains, sites frequented by weekend visitors and local residents alike. The Armuchee Ranger District of the Chattahoochee National Forest comprises no fewer than 66,000 acres of public land in the area, incorporating portions of six northwest Georgia counties.

From an ecological perspective, the Armuchee Ridges are truly distinctive. The mountains are at a biological crossroads, containing numerous plant species from the northern and southern end of their range. Because of its diverse ecology and natural beauty, the area received attention from the U.S. Congress, who, in 1992, temporarily stopped all logging activities in many portions of the Armuchee Ranger District of the Chattahoochee National Forest.

Not only do the northwest Georgia mountain region display a unique geology and natural history, it is also rich in human history. This corner of Georgia was also the heart of the former Cherokee Nation, which had its capital at New Echota near Calhoun. Pioneer settlers also worked the land, leaving their own cultural imprint on the landscape. Later in the century, mine prospectors and their employees dug deep into the mountains, uncovering thousands of tons of precious ores for the insatiable engines of commerce and industry. In the area's wide and rich river valleys, cotton truly became king, promoting the development of the selling and manufacturing of a whole array of cotton products in the area, including tufted linens and bedspreads. While there are few signs of these previously vital industries, abandoned homesteads and mining sites can still be seen throughout the mountain region, marking a way of life almost forgotten.

Among the first inhabitants of the northwest Georgia mountains were the Mississippians, mound builders who built permanent settlements along the area's largest river valleys. During the 17th century, after the collapse of Mississippian culture due to disease and famine, the Cherokees began calling northwest Georgia home. Soon, they too would see their demise as white settlers forced their removal in an exodus now known as the "Trail of Tears."

As a result of settlement during the early 19th century, all of northwest Georgia was divided into rectangular 160-acre land lots and distributed by lottery to prospective settlers. These lots were originally mapped by district surveyors who used standing trees as boundary markers. By examining these original survey land plats, it is now possible to reconstruct the original composition of the mountain forests. Oaks, hickories, and chestnuts dominated much of the northwest Georgia landscape, with pines occurring only on drier slopes or near abandoned Cherokee homesites.

Within decades, a growing white population brought the need for improved commercial transport, which made the region's largest rivers important arteries for commerce and trade. During the antebellum period, both slaves and cotton were transported down the Conasauga and Ooostanauala to Rome, then a major river-port town. Steamboats were not entirely uncommon sights on these rivers, particularly during spring freshets when water levels were at their peak.

Mineral Springs were another important resource of the northwest Georgia mountain region, as the "taking of healthful waters" had developed into a popular ritual for most Southerners prior to the Civil War. During the warm summer months, people would visit as many mineral springs as possible, taking advantage of their tonic and soothing effects. By 1850, Catoosa Springs near Ringgold had become renown for its many unique and varied waters. At that time, there were more than 52 visible springs on the site. Names were given for the various waters, and a large hotel and guest cottages were soon built to accommodate more than 500 guests. In 1861, Catoosa Springs was proclaimed the "Saratoga of the South," and by the turn of the century, waters from the springs were being bottled and shipped to all parts of the United States.

Underneath the northwest Georgia mountains lay an abundance of valuable minerals: talc, bauxite, shale, and the numerous ores for making iron. Geologists and mine prospectors scouting the mountains soon discovered these seams, and commercial mining activities prospered across the region. In fact, the first discovery of bauxite in North America was made at Hermitage in Floyd County in 1887, and this mine supplied much of the domestic supply for more than a decade. Iron ore was mined extensively along Taylor's Ridge in Walker, Catoosa, and Whitfield Counties, as well as in Sugar Valley in Gordon County. Talc, a powdery mineral with a number of industrial and commercial uses, was heavily mined in Murray County, near the foot of Fort Mountain, becoming no small industry there by the turn of the 20th century.

The clearing of mountain forests for mines and agriculture attracted the attention of the National Forest Service, which began purchasing private lands in the region in 1937. A decade earlier, the state geologist had declared the region mineral as poor, thereby making it a prime candidate for the emerging National Forest system. The 250,000-acre Armuchee Ranger District was created at that time, a purchase unit that was added to the already formed Chattahoochee National Forest. After World War II, the budget for land acquisitions was slashed, leaving only 65,000 acres of the original 250,000-acre purchase unit under federal ownership. The Civilian Conservation Corps had several encampments within the boundaries of the Armuchee Ranger District; their handiwork is still visible today.

Both corn and cotton grew well in the fertile valleys of the mountain region, but cotton had become the major cash crop by the late 19th century. Cotton was grown on almost every farm, and schoolchildren were released from school each fall to help harvest the annual crop. Cotton production also helped to stimulate the textile industry, a chief employer of area residents for most of the first half of the 20th century. The Great Depression deflated cotton prices but created the impetus for home crafts such as bedspreads and other tufted linen products. Today, the area is better known for its carpet manufacturing, and thousands of newcomers call the region home.

Northwest Georgia. A Land of Ridge and Valley. A place rich in history, a past to be preserved.

One

SETTLING THE LANDSCAPE

The first people to permanently inhabit the ridges and valleys of northwest Georgia were the Mississippians. From 900 to 1200 A.D., Mississippian civilization developed into a network of state-like chiefdoms that reigned over the entire southern mountains. Mississippians were primarily valley dwellers, making their major settlements along major river bottoms. Villages were established at these sites not only because of the availability of easily tilled soils but also because of their proximity to a wide range of plant and animal life. Their proximity to water also provided the Mississippians a route for their dugout canoes, used to transport food and other goods to distant villages up or downstream.

Perhaps unique to Mississippian village sites are the large earthen platform mounds that were centrally located above the town's main plaza. The Etowah Mound, located in Bartow County, is one of the best examples of Mississippian platform mounds. Mississippians directed all their public activity toward the structure built atop these mounds, a sacred temple that also served as the residence of the principal ruler.

Of course, the Mississippians were not the first native group to play a role in shaping the landscape of northwest Georgia. Archeological evidence confirms human disturbance in the area over the last 10,000 years. The Mississippians did, however, intensify that rate of change. As villages increased in size and social complexity, the additional clearing of land for settlement and cultivation became necessary in order to keep pace with the demands of a growing population.

Mississippian civilization reigned supreme in northwest Georgia until the mid-16th century, after Hernando De Soto visited the area in 1540. De Soto and other Spanish explorers who came in contact with the Mississippian population were carriers of fatal epidemic diseases, making these explorers directly responsible for the rapid decline and eventual demise of the Mississippians. According to one estimate, for every 20 Native Americans present in northwest Georgia at the time of De Soto's entrada into the area, only 1 survived.

Spanish exploration in the mountain region greatly influenced the social and cultural development of the Cherokee Indians, the Native Americans most often associated with

northwest Georgia's Land of Ridge and Valley. Within only a century after the initial Spanish contact, the Mississippians had been transformed into the Qualla—the ancestral peoples of the modern Cherokees. The Qualla Cherokees continued many of the cultural practices of their Mississippian ancestors, including mud-and-thatch building construction and river-cane basketry. By the early 1700s, permanent Cherokee settlements were found scattered across the northwest Georgia mountains.

From the early 1700s until their removal in 1838, the Cherokee people made the mountains of northwest Georgia an integral part of their culture. Northwest Georgia Cherokees consumed deer, elk, buffalo, and even beaver in great quantities, and skins of these animals provided essential clothing. As animals became more scarce in the surrounding forests, the Cherokees slowly began to adopt the use of European clothing. By 1800, many Cherokees preferred smooth cotton broadcloths over animal skins or feathers. No longer self-sufficing natives, many Cherokees were dependent upon the European for literally putting clothes on their backs.

After the forced removal of the Cherokees in 1838, white settlers began pouring into the northwest Georgia mountains, settling lands won in the Cherokee Land Lottery. Among the first whites in the northwest Georgia mountains were livestock drovers who ranged cattle across fertile woodland valleys and along ridgetops. The proliferation of hogs and cattle throughout the mountains was not without important environmental consequences. Across the uplands, particularly in areas going through the natural secession of recovering from heavy timber cutting, grazing livestock suppressed the growth of young saplings and herbaceous plants. Cattle drovers also burned the woods annually to "green-up" the forest floor, which help to sprout new growth for the ranging animals.

Over time, particularly in areas receiving heavy livestock use, the result was a more open park-like effect, with greater distances between standing trees. In many of the most disturbed areas, non-native plants such as privet, multifloral rose, and mullein, to name only a few, rapidly replaced native vegetation.

It was crop production, not cattle droving, that interested mountain men the most. A successful agriculturalist needed large grain supplies to feed his horses, hogs, and poultry. Because it served as food to both livestock and humans, corn remained the principal crop in the region until at least the Civil War. Growing corn took a substantial amount of land, although very few farmers in the area tilled more than 20 acres for that purpose.

Corn was not only used as a primary foodstuff, it was also ground into meal, made into whiskey, and its husks and leaves were woven into hats, dolls, mops, and chair bottoms. Corn cobs served as primitive toilet paper, fire-starters, bowls for tobacco pipes, and hog and cattle fodder. The harvesting of corn greatly influenced social relations in northwest Georgia as well, bringing neighbors together for annual fall cornshuckings.

After the Civil War, the crop diversity of the northwest Georgia farm begin giving way to a single crop—cotton, which by the 1880s had replaced corn as the dominant cash crop. The Civil War had a tremendous impact on the region and recovery was slow. Cash was scarce and political revenge frequent. Overall, farming suffered greatly after the war, with noticeable reductions in improved land and crop production. Pines, sweetgum, and sassafras invaded untended fields where corn and wheat had once grown thick and tall in the warm sunlight.

Into this social and economic vacuum entered a new wave of entrepreneurs, land speculators, and mining industrialists with an eye for transforming the ridges and valleys of northwest Georgia into a private domain of capital and wealth. Many communities in the area clearly owe their existence to these undertakings, which pumped vital resources into a stagnant, if not dying economy. Other townships were well established, but they boomed as a result of these industrial activities. In any event, the settlement pattern of northwest Georgia had clearly been established by 1900, and would remain relatively unchanged for another half-century.

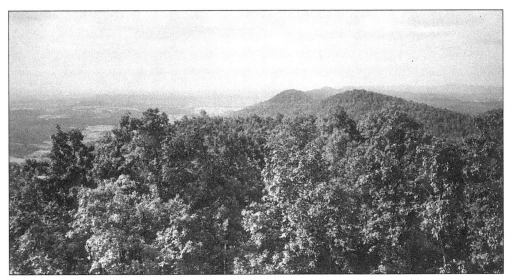

Taylor's Ridge, in Walker County, affords many spectacular views of northwest Georgia's fertile valleys. Taken around 1941, this photo was taken from "The Narrows" fire tower and shows a largely contiguous stand of oaks, hickories, and numerous other mixed hardwood species. The Narrows fire tower was constructed in 1941 by the Civilian Conservation Corps. (Courtesy of U.S. Forest Service, Armuchee Ranger District.)

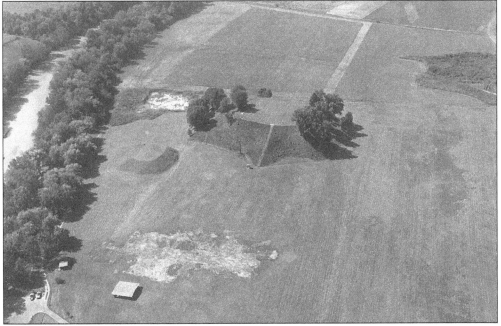

The first people to inhabit the mountains of northwest Georgia in permanent settlements were the Mississippians. At the time of first Spanish contact in 1540, the Mississippians were well established along northwest Georgia's major rivers and tributaries. Perhaps unique to Mississippian village sites are the large earthen platform mounds that were centrally located above the town's main plaza. Mound A, at Etowah, rises to approximately 63 feet, and covers more than 3 acres at its base. (Courtesy of Waring Archaeological Laboratory, State University of West Georgia.)

11

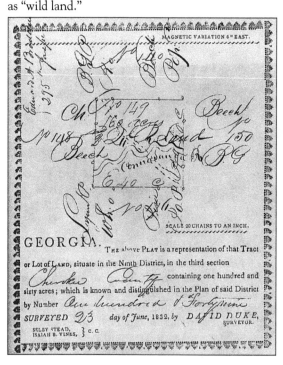

In 1831, northwest or "Cherokee" Georgia was surveyed by order of the governor into four sections, and these sections were further subdivided into land districts 9 miles square. Sixty districts, including all the counties depicted in *The Land of Ridge and Valley*, were laid off into 160-acre "landlots." People were then allowed to draw for these lots in a public lottery, for a fee ranging from $3 to $18. Some lots were never claimed and later became known as "wild land."

After 1831, all landlots occupied by Cherokees were surveyed and evaluated for their worth so that "just" compensation could be granted to them after their removal. These individual landlot plat maps are important documents for environmental historians because trees were used as boundary markers for each survey. By tallying up the number of specific tree species recorded on each plat map, it is possible to create a fairly accurate portrait of the 18th-century mountain forest. Here is the survey plat of Lot 149-9-3, in Murray County, which shows numerous beech trees growing along the Conasauga River.

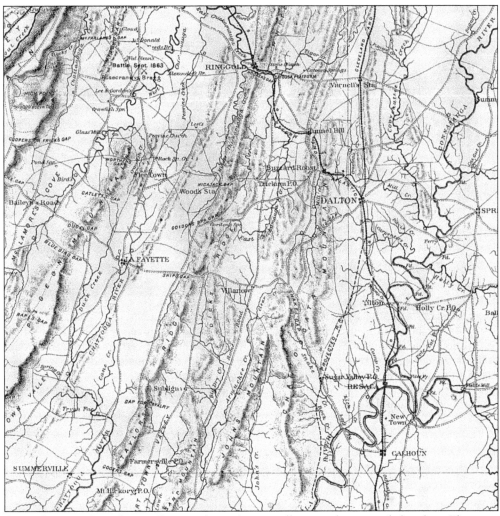

An early map of northwest Georgia shows former villages and crossroads hamlets. This map was originally prepared by Col. William E. Merrill, chief engineer of the Army of the Cumberland, 1865.

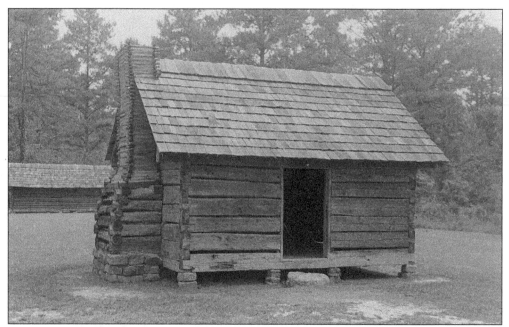

Despite their noted influence on mountain life and culture, 19th-century Cherokees utilized the surrounding countryside in much the same way as frontier settlers, particularly those Cherokees living in northwest Georgia. By that time, the surrounding landscape was valued more for its ability to grow corn, wheat, or cotton or to provide pasture for livestock. Cherokees also made use of the wheel, loom, plow, and wore Anglo-style clothing. (Courtesy of Georgia Department of Natural Resources.)

Among the first and most important crops introduced by the Spanish to northwest Georgia were peaches. Spanish colonists first brought peaches to northern Florida and South Georgia, where they served as a food source. The peach was so central to the culture of the Native Indians that early settlers referred to this Old World fruit as the "Indian peach."

Located on the Chipola farm in Murray County, this log structure contains logs from actual Cherokee dwellings once located at this site. The use of logs was not uncommon in Cherokee building design, but the dovetail notching is German or Finnish in origin. In the 20th century, this structure was used primarily as a corn crib or hog pen. (Courtesy of Whitfield-Murray Historical Society.)

An early map of northwest Georgia shows original county borders and early settlements, c. 1840.

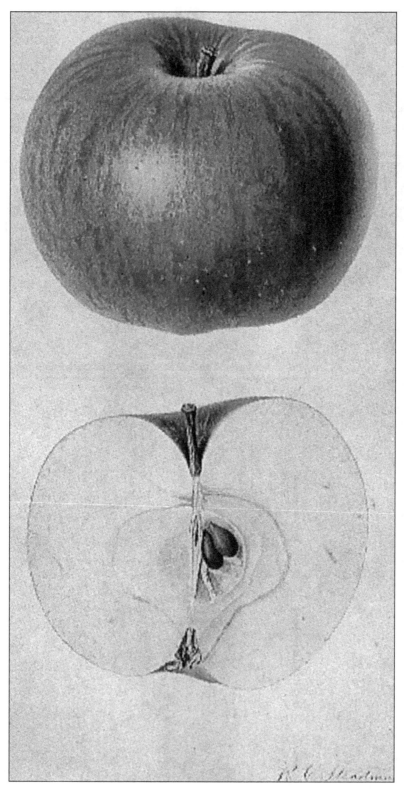

Apples like these were once grown by the Cherokees, who are indirectly responsible for reviving the apple-growing industry in the South. In the 1850s, Jervis Van Buren founded the Georgia Pomological Society, and grafts from trees collected at former Cherokee homesites were used to start new orchards. This artist's rendering of the "Nickajack" apple, today an heirloom species, was done by R.C. Steadman for the U.S. Department of Agriculture in 1925.

Recognizing the necessity of roads in the lower Tennessee Valley for stimulating commerce, James Vann, a prominent Cherokee planter and merchant, initiated the building of the Federal Road, the first route to bisect the entire Cherokee Nation. Completed in 1807, the road connected Nashville to Augusta, Georgia. At the two major Cherokee toll gates, the rates were fairly typical of the period: wagon and team, $1; two-wheeled carriage, 50¢; man and horse, 12¢; hogs, sheep, and goats, 1¢ per head.

Although it has been nearly 200 years since its original construction, traces of the Old Federal Road can still be seen across much of northwest Georgia. Years of horse, foot, and wagon travel have carved in northwest Georgia narrow, yet visible, swaths through the countryside, leaving an important historical legacy for future generations to map and explore. This photograph was taken near Oakman, in Gordon County, in 1997.

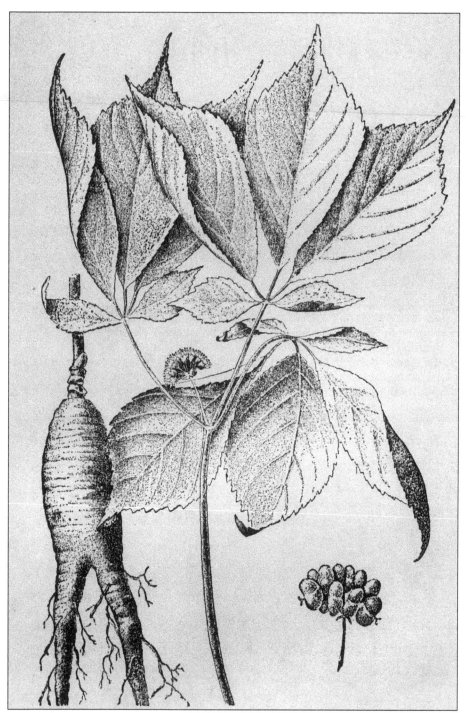

Ginseng, a valuable commodity on the global market since the mid-18th century, grows among the rich deciduous forests of the northwest Georgia mountains, particularly on northern facing slopes above 1,500 feet in elevation. The Cherokees were extremely familiar with the plant since they, like the Chinese who readily purchased the root, believed it to have important medicinal qualities.

In 1827, the Cherokee Nation established a national newspaper, the *Cherokee Phoenix*, at New Echota. The printing press, which was shipped from Boston, was housed in this building, a faithful reconstruction of the original structure. Edited by Elias Boudinot, the newspaper was the first in America to be published in a Native American language. An English version was also printed and both versions served as important voices for the Cherokee cause. (Courtesy of Georgia Department of Natural Resources.)

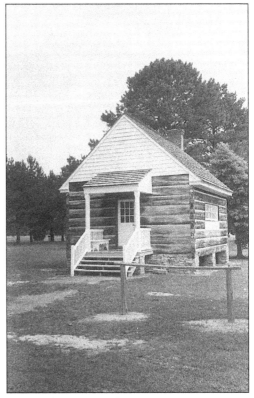

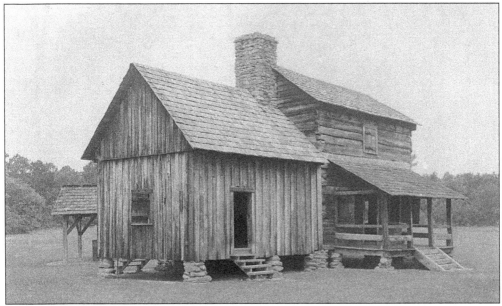

This log structure is an original Cherokee tavern that was built by James Vann, a wealthy Cherokee merchant and plantation owner. This and several other northwest Georgia taverns served travelers along the Federal Road, which was the main route through the area until the coming of the railroad in the early 1850s. (Courtesy of Georgia Department of Natural Resources.)

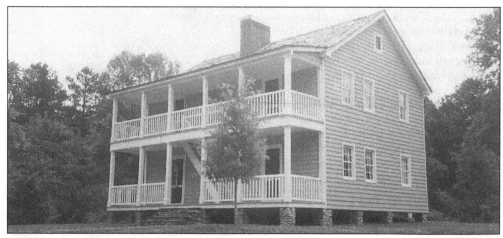

The Worchester home at New Echota State Park in Calhoun was constructed in 1828 and later restored in 1958. Samuel A. Worchester and his family lived here, but the home also served as a Presbyterian Mission Station. Worchester, a Presbyterian minister, started a church and school at New Echota, but he is perhaps best known for being imprisoned for opposing the removal the Cherokee from their homelands. Worchester moved with the Cherokees to Oklahoma in 1835, where he continued to work for Cherokee causes. (Courtesy of Georgia Department of Natural Resources.)

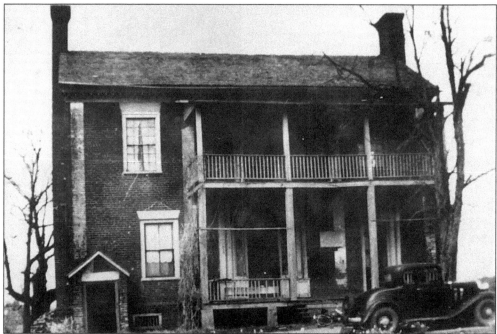

Pictured is the historic Vann House at Spring Place, Murray County during the 1930s, when the home was in considerable disrepair. The home was designed by a German architect for Cherokee Chief James Vann, a mixed-blood plantation owner and one of the wealthiest men in Georgia during the early 1800s. The home was completed in 1805 and the labor of slaves and local Moravians was used in its construction. The home was completely restored during the 1950s, and was re-opened to the public with much fanfare and celebration on July 27, 1958. (Courtesy of Crown Gardens and Archives.)

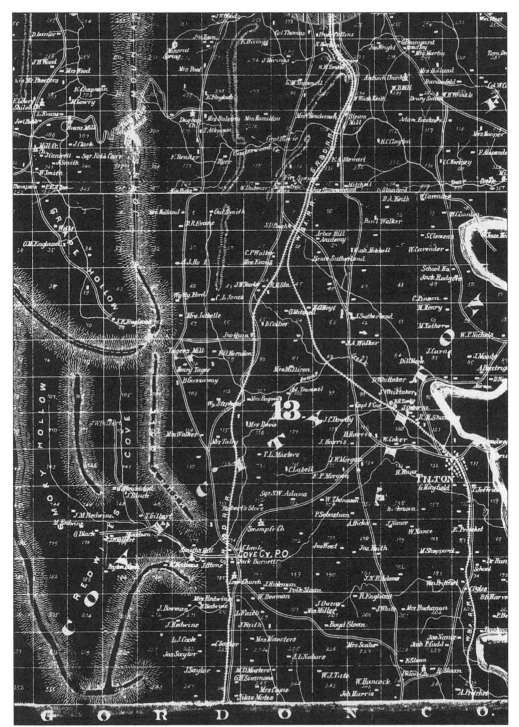

A map of Whitfield County, 1879, shows original landlots and their occupants. Note wide areas of "unclaimed" lands, indicative of a land consolidation process that occurred largely after the Civil War. Many lots were purchased by single landowners, usually mining companies, in more remote mountainous areas that were harder to farm.

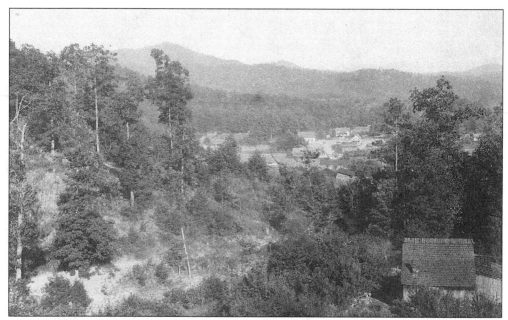

A rare glimpse of Cisco, in north Murray County, as it appeared in 1919, shows Doogan Mountain rising in the background on the left. This photograph was taken in September, probably by state geologist J.W. McCallie, who toured the area at that time. (Courtesy of Georgia Department of Archives and History.)

When good bottomland was unavailable, the rolling hillsides of northwest Georgia were often planted with corn. This photograph was captured by O.B. Hopkins in July 1914 near Fairmont in Bartow County. (Courtesy of Georgia Department of Archives and History)

This c. 1923 photograph shows Sharp Top Mountain, as seen from Mineral Springs Road, 5 miles south of Jasper in Pickens County. (Courtesy of Georgia Department of Archives and History.)

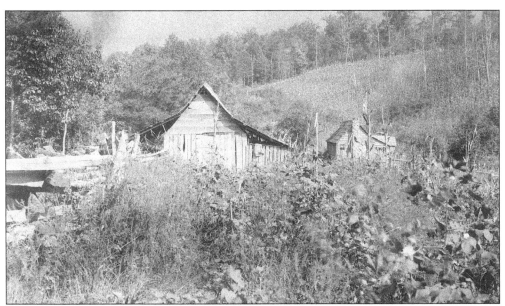

Dated September 1919, this unusually early photograph of the northwest Georgia mountains was taken along the west side of Buckeye Mountain in Fannin County. The homestead belonged to Preacher Hall and is more typical of Blue Ridge mountain farmsteads, which depended far more on corn than cotton. Note the five-rail-high fence. (Courtesy of Georgia Department of Archives and History.)

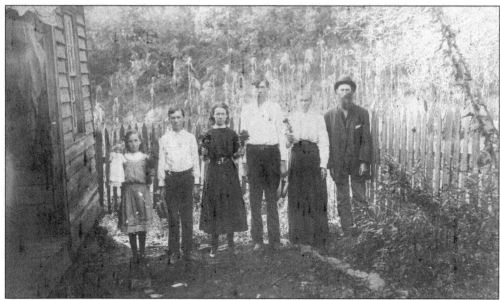

Although only a small portion of Gilmer County lies officially within the boundaries of the northwest Georgia mountain region, many of its residents, particularly those in the western part of the county, share a similar history. Here are members of the James Ellis family who have gathered outside their Pleasant Hill home with their most prized material possessions: a doll, hat, and bunches of flowers. Shown in this *c.* 1910 photograph, from left to right, are Ina, John, Ida, Glenn, and Mrs. and Mr. James Ellis. (Courtesy of Georgia Department of Archives and History.)

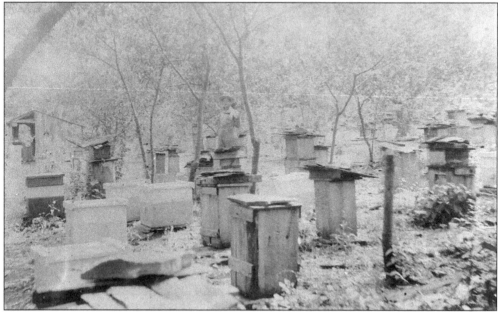

This photo, taken after 1900 in Murray County, shows a typical bee-yard of the northwest Georgia mountains. During the early 20th century, most of the hives or "supers" were made by hand from hollow logs, but a few of the hives were commercially constructed. (Courtesy of Georgia Department of Archives and History.)

This image, one of the earliest known photographs of Dalton and its northern environs, was taken in 1890 atop Stand Pipe Hill, a low ridge slightly north and west of the present city. The tree in the right foreground appears to be the now virtually extinct American Chestnut, a species whose narrow serrated leaves once provided easy identification. (Courtesy of Georgia Department of Archives and History.)

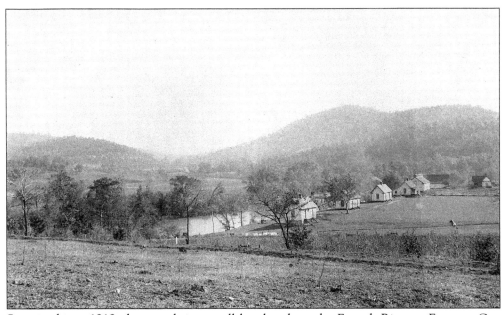

Seen in this c. 1919 photograph is a small hamlet along the Etowah River at Emerson Gap near Cartersville in Bartow County. Note the electric utility poles and central chimney plan of freshly painted dwellings. (Courtesy of Georgia Department of Archives and History.)

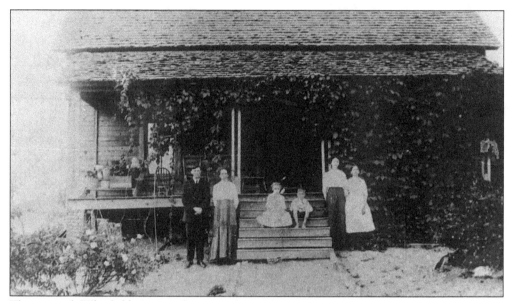

This typical Whitfield County homestead was located in the River Bend area of Tilton and features unique period landscaping, which included the planting of morning glories along the front porch. Pictured, from left to right, are James Brown, Mary McGaha Brown, Olivia H. Westbrook, Roy Brown, Mami Finley, and Ruth C. Stiles. (Courtesy of Crown Gardens and Archives.)

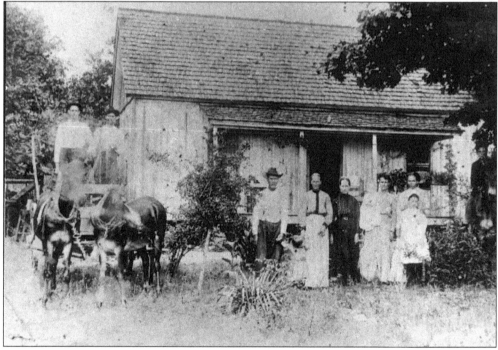

Two sharecropping families—the McGahas and Cowarts—pose for a photograph on land that was once part of the Walnut Grove Plantation in south Whitfield County. George McGaha is the tallest man in the wagon. Because he also owned the mule and wagon, he was reportedly able to keep a larger share of the crops produced. (Courtesy of Crown Gardens and Archives.)

Unidentified children pose in front of the Clisby-Austin house, *c.* 1920, in Tunnel Hill. During the Civil War, the home served both as a temporary headquarters for General Tecumseh Sherman and as a Confederate hospital. Note the fenced cattle and the protected garden. After the passage and enforcement of fence laws during the late 19th century, cattle no longer free-ranged in the northwest Georgia mountains.(Courtesy of Bradley Putnam.)

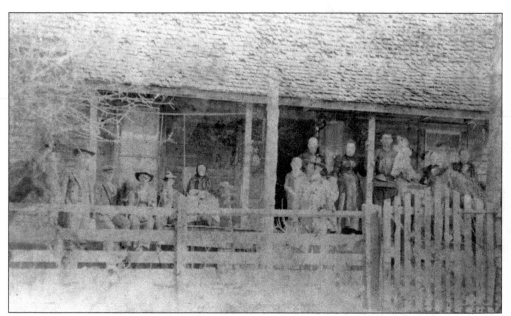

This c. 1900 photograph shows the Ross family in front of their Catoosa County homestead, built in the late 1890s. Lemuel Ross, the family patriarch, is standing in the center of the photograph. He was captured during the Civil War at Petersburg, Virginia, and released from a prisoner of war camp at Point Lookout, Maryland. (Courtesy of Janie Ross Davis.)

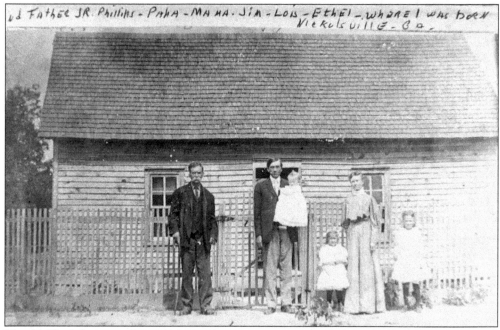

The Phillips' homestead in Nicholsville was sometimes called Little Five Points, a small farming community in northern Gordon County. The Phillips family owned several general stores in the area and grew cotton, corn, and wheat on their large land holdings. This is a c. 1905 photograph. (Courtesy of Bradley Putnam.)

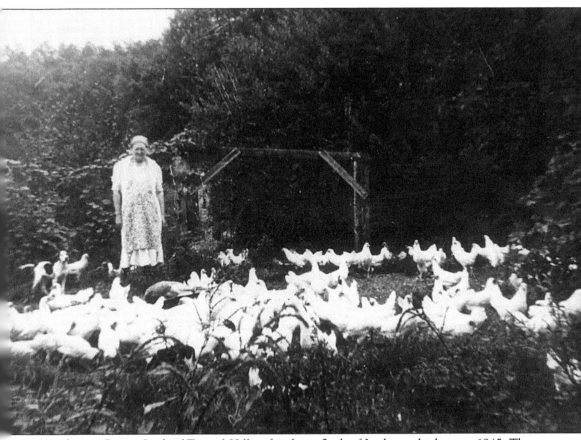

Seen here is Roma Cook of Tunnel Hill with a large flock of Leghorn chickens, c. 1945. The raising of poultry was largely a woman's domain throughout most of southern Appalachia, including most northwest Georgia communities. Money made from selling eggs and pullets was often referred to as "pin money" and could be a primary source of income for women. Mattie Boggs Davis of Catoosa County once remarked that the largest debt owed her was a loan made to a son-in-law of her entire life savings—$325—that she earned "when eggs were a good price for that purpose." (Courtesy of Bradley Putnam.)

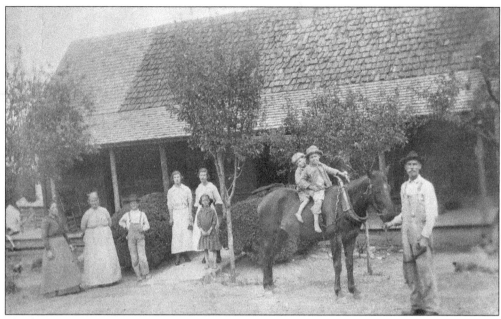

Three generations of the Hinkle family stand in front of their home in Whitfield County. The home was located at the intersection of Varnell and Waring Roads and featured wooden shingles and a central chimney plan. The photograph was taken around 1910 and was later made into a mailable postcard that was sent to family and friends. (Courtesy of Whitfield-Murray Historical Society.)

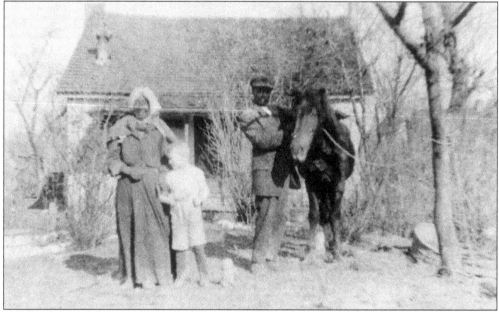

African Americans have made important contributions to the northwest Georgia mountains, although historic photographs documenting their widespread presence in the region are sorely lacking. Photographed here is Lizzie and Martin Jackson of Tunnel Hill, along with their young neighbor Paul Stevenson. Sadly, Lizzie Jackson died in a house fire in the 1940s, 20 years after the photograph was taken, c. 1924. (Courtesy of Bradley Putnam.)

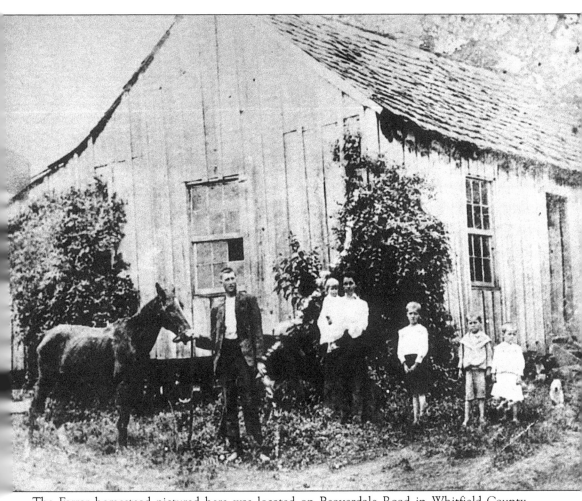

The Farrar homestead pictured here was located on Beaverdale Road in Whitfield County during the early 20th century. The home is a good example of a "box" house, which is architecturally characterized by vertical board-and-batten construction. Pictured, from left to right, are Daniel Boone Farrar, Mary Susan Farrar, Susan Farrar (in mother's arms), Clarence Farrar, William Farrar, and Albert Farrar. This is a photograph c. 1910. (Courtesy of Whitfield-Murray Historical Society.)

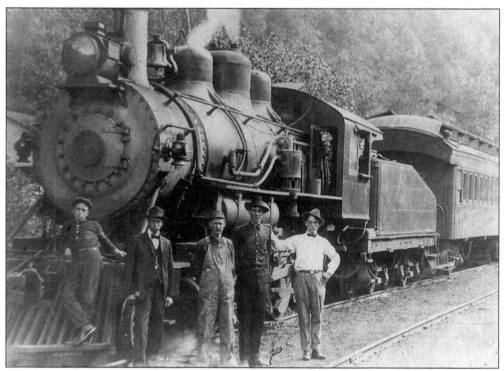

Standing at the far right is Floyd Messer, a steam engine enthusiast of German heritage. This photograph was taken along the rail line near Chatsworth in Murray County, c. 1940. (Courtesy of June Edmondson.)

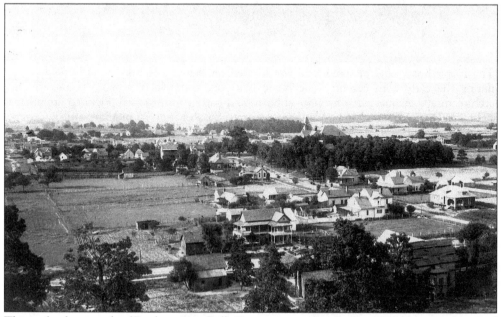

This early photograph of Rockmart, in Polk County, was taken before 1920 by an unidentified state geologist touring the area at that time. (Courtesy of Georgia Department of Archives and History.)

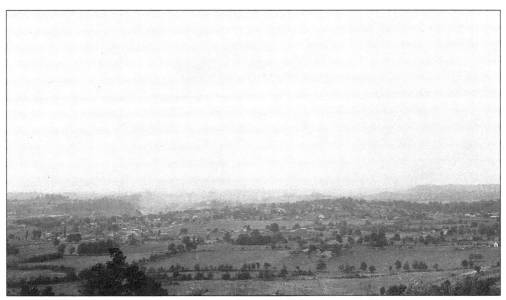

An unusual view of Rome, Georgia, shown here, was taken from a hill southeast of the city in 1923. (Courtesy of Georgia Department of Archives and History.)

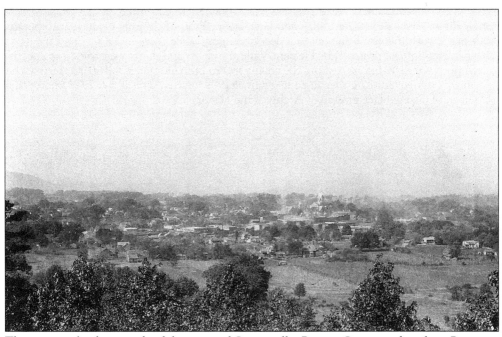

This is an early photograph of the town of Cartersville, Bartow County, taken from Reservoir Hill in November 1919. (Courtesy of Georgia Department of Archives and History.)

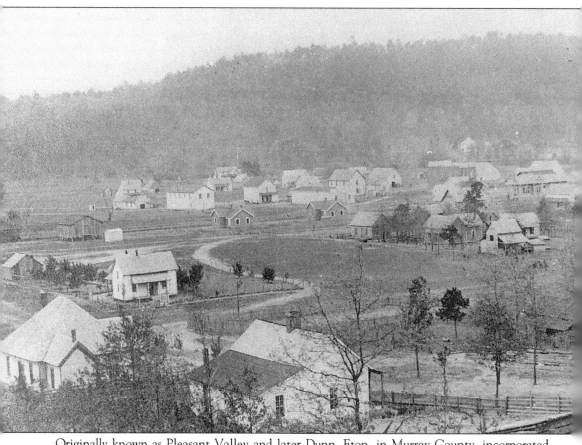

Originally known as Pleasant Valley and later Dunn, Eton, in Murray County, incorporated both places with the establishment of a depot and post office there in 1906. The Eton Town Company was formed primarily by Pleasant Valley residents and shares were sold to prospective owners for $100 each. Efforts to move the county seat to Eton ultimately failed, but the town has remained a self-governing entity since its original 1909 charter. This is a c. 1912 photograph. (Courtesy of Georgia Department of Archives and History.)

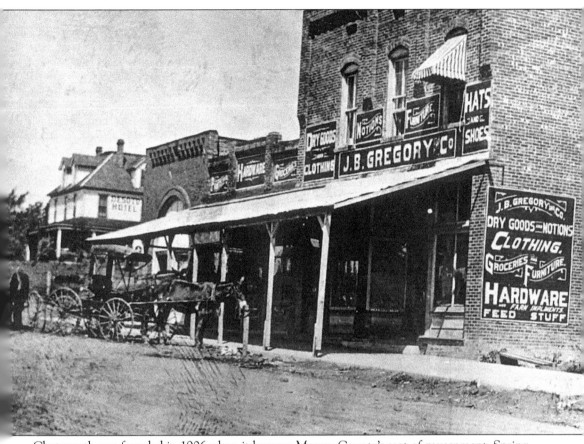

Chatsworth was founded in 1906 when it became Murray County's seat of government. Spring Place, 3 miles to the west, had been the county seat since 1833, but Chatsworth's prime railroad location made it a much more logical choice for the county seat. Note the large DeSoto Hotel, constructed in 1907. This photograph was taken *c.* 1910. (Courtesy of Crown Gardens and Archives).

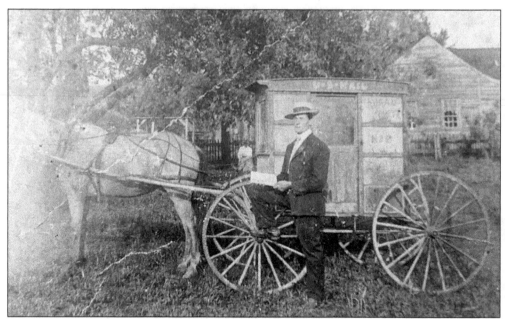

W.J. Hammondtree, postmaster of Tunnel Hill, was appointed a rural mail carrier in 1907 around the time this photograph was taken. Before his retirement in 1945, Hammondtree reportedly traveled more than 160,000 miles on either horseback or in a horse and buggy, and more than 72,000 miles on foot. (Courtesy of Bradley Putnam.)

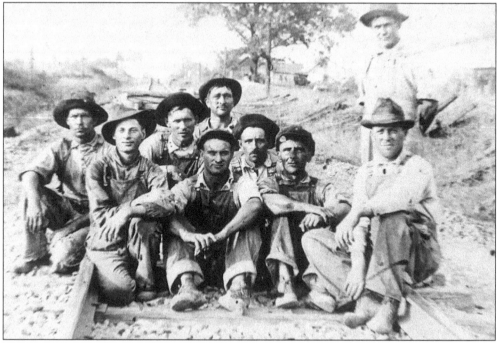

This picture was taken on September 29, 1922 and shows people who are working on the railroad at Rocky Face, Whitfield County, Georgia. Pictured, from left to right, are (first row) Dennis Calhoun, an unidentified worker, Jack McGomery, and George McAffee. The person who is standing is the crew foreman, Gene Suggs. (Courtesy of Bradley Putnam.)

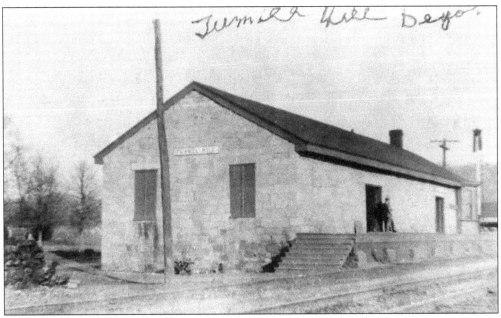

The Tunnel Hill Depot was made from quarried stone and photographed *c.* 1900. Many historic depots have been restored in the region and remain important symbols of the area's pre-automobile past. (Courtesy of Bradley Putnam.)

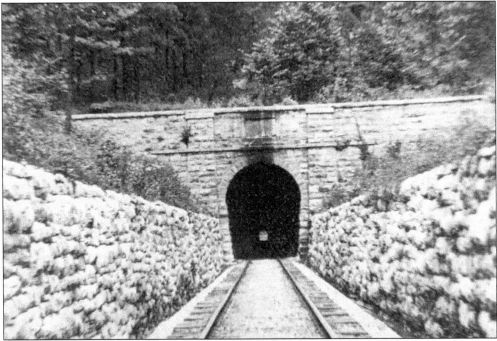

The railroad tunnel at Tunnel Hill, in Whitfield County, remains one of the region's most historic and recognizable landmarks. Excavation for the tunnel began in 1848 and the first train of cars passed through the opening on May 9, 1850. The completion of the tunnel was marked by a large celebration, which included numerous public speeches and the firing of a large cannon. This photograph was taken *c.* 1900. (Courtesy of Bradley Putnam.)

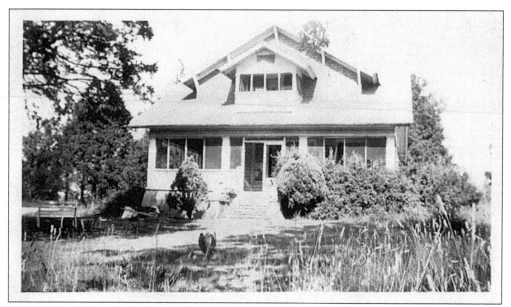

By the early 20th century, there was a much greater diversity of architectural styles in northwest Georgia, including homes that borrowed from the designs of the late-19th-century Arts and Crafts movement. A good example is the Sutton home, built in 1907 by Grady Sutton, a character actor in Hollywood films. The Sutton family, who also owned a nearby sawmill, later sold the home to the Messer family of Catoosa County. The photograph is c. 1929. (Courtesy of June Edmondson.)

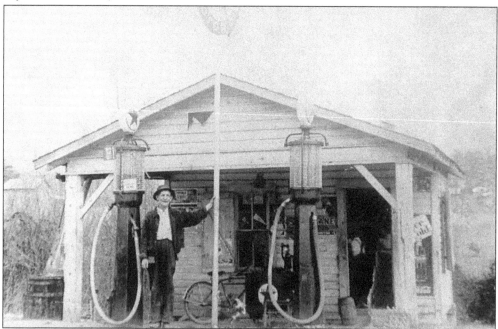

The completion of Highway 41 through the area spawned a number of new businesses, including gas stations and roadside motels. James Roberson of Rocky Face, in Whitfield County, stands in front of one of the first Texaco stations in the area, c. 1942. (Courtesy of Bradley Putnam.)

Two

WATERS OF LIFE

The Land of Ridge and Valley has always been blessed with water, containing numerous springs, creeks, and rivers within its borders. The northwest Georgia mountains are actually drained by two river basins: the Tennessee River Basin and the Coosa River Basin. Most of the area remains within the Coosa River valley, however, so nearly all northwest Georgia streams and rivers have a southerly flow.

Creeks and rivers were extremely important to the early settlement of the region, as waterpower was needed to drive the ever-important gristmill and sawmill. Gristmills were often the focal point of community life and hardly anyone lived more than a half-day horse-and-buggy-ride away from the local miller. Millponds were also favorite spots for fishing, picnics, and group baptisms. Gristmills harnessed the energy of the areas swift moving streams and turned corn and wheat into nutritious meal and flour. Gristmills also attracted other important enterprises, and so a visit to the local millhouse was a monthly, if not weekly, outing.

Early travel in the mountains was directly dependent upon the flow of water, as high waters from spring or summer freshets severely limited excursions beyond a creek's swollen banks. Of course one could always float down the river in a kneel boat or canoe, an excursion made less arduous after the invention of the outboard motor in the 1920s. Water levels directed traffic in other ways as well—ford crossings were always dug at the shallowest point in the creek or river, giving wagons and horses an easy crossing point.

Northwest Georgia's three most important rivers include the Oostanaula, Etowah, and Conasauga, although the Coosa is the largest before it flows outside the region's boundaries at its most southern end. The Conasauga River, the fastest flowing of the three, has a unique and most interesting history. In the 19th century, it was known locally as the "Slave River" because of the great number of slaves who manned flatboats along its waters. The Conasauga was a major artery for transporting mountain furs and peltry to the Gulf of Mexico, and early eyewitness accounts recall hearing their voices "in songs, shouts, or murmuring . . . far beyond the river's banks."

Sawmill operations also sprang up along the Conasauga River, including a large one at Tilton, owned and operated by Wiley J. Ault. Ault took advantage of the well-wooded bottomlands along the banks of the river, cutting down enormous trees that had gone un-cut for more than 100 years. The trees were often floated down the river in large rafts to a point where they could be safely extricated from the water's edge and then sawed into boards. Log rafts were not uncommon sights on northwest Georgia's rivers, particularly during the heyday of industrial logging, which peaked sometime during the 1920s.

Riverboat traffic was also not uncommon on northwest Georgia's major rivers, especially after the Civil War. Steamboats regularly made their way up the Coosawattee, Conasauga, and Oostanaula Rivers, especially during highwater season, which generally lasted from November to May. Steamboats came upriver to load cotton, lumber, wheat, and oats, which were shipped to markets in Rome and major ports further downstream. Several steamboat companies were formed in the region before 1880, and the boats themselves were given names that reflected the local character of the enterprises. Boats making regular trips upstream include the *Hill City*, *Sport*, *Dixie*, *Mitchell*, *Resaca*, and the *Coosawattee*.

Mineral springs were also incredibly abundant in the northwest Georgia mountains and drew numerous visitors from across the South. For most of the 19th century, mineral springs were sought after for their tonic and soothing effects. Water "cures" were also very popular among physicians of the era who would prescribe the drinking of various mineral waters for such illnesses as dyspepsia, gout, and skin disorders. Chemists routinely tested the composition of mineral waters and their various properties were published routinely in popular books and magazines of the period.

Perhaps the Land of Ridge and Valley's most well-known basin of mineral water was Catoosa Springs near Keith in Catoosa County. At that time there were more than 52 visible springs on the site, almost all with varying mineral properties. A large hotel and several row cottages were built to accommodate guests, and by 1861, Catoosa Springs was proclaimed "The Saratoga of the Confederate States." During the Civil War, Catoosa Springs became the site of several Confederate Hospitals. Many of the sick soldiers were able to return to duty after drinking or bathing in the mineral waters.

In times past, mineral springs were favorite gathering places for families and friends, especially during summer months, when such places served as weekend retreats. Mineral springs were far more than a source for water: they served as a place were people could nourish and replenish their bodies and reflect in the quiet serenity and beauty of the grounds. They were indeed "waters of life."

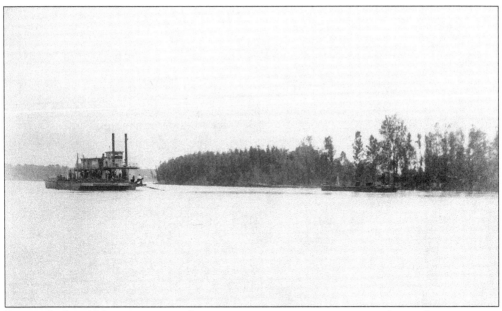

During the late 19th century, steamboats were not an uncommon site on the area's major rivers, especially during spring months when water levels were at their greatest. Here, a tugboat pulls a steamer through the narrow channels of the Oostanaula River near Calhoun. This photograph was taken in 1886 and is the oldest in *The Land of Ridge and Valley* collection. (Courtesy of Georgia Department of Archives and History.)

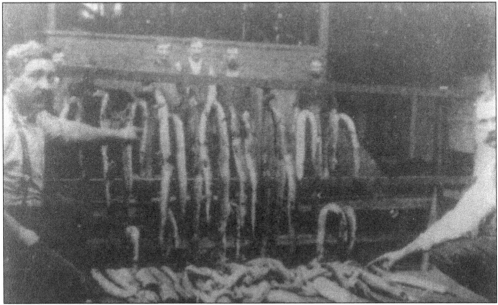

Before the building of dams for electricity and flood control, American eels, a migratory species, swam by the thousands in northwest Georgia rivers. These eels were captured by the millworks at the Trion Mill in Trion, Georgia. In fact, such a large number of them existed that they jammed the water wheel, which cut off power, and closed operations. The two men, Mr. Wooten and Mr. Worthy, carried away no fewer than three wagon loads of eels before work could be resumed.

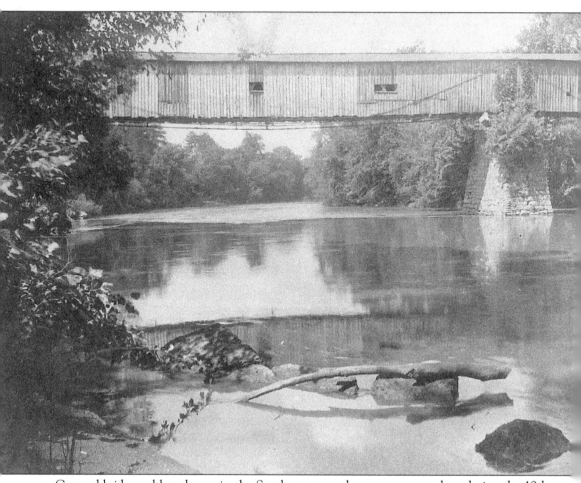

Covered bridges, although rare in the South, were much more commonplace during the 19th century, when travel by horse and carriage was the rule rather than the exception. This covered bridge was built in the early 1870s and spanned the Oostanaula River in Gordon County. Sadly, the bridge collapsed in 1917 after turgid floodwaters swept over the wooden structure. This photograph was taken *c.* 1912. (Courtesy of Georgia Department of Archives and History.)

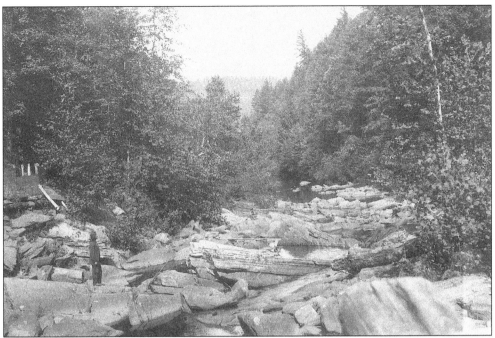

This is an early view of the Conasauga River as it approaches the Alaculsey Valley in Murray County. The Conasauga River is one of the most pristine rivers in the eastern United States and is home to numerous endangered fish and mussels. This photograph was taken in 1914 by state geologist S.W. McCallie. (Courtesy of Georgia Department of Archives and History.)

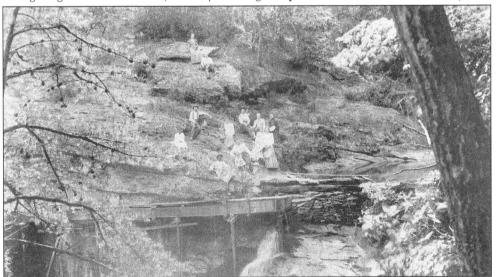

Picnickers enjoy the environs at the headwaters of Euharlee Creek above Hightower Falls in Polk County. Spring-fed mountain streams were often used for refrigeration, such as cooling milk and butter during the warmest summer months. Such sites attracted young and old alike, providing a much-needed escape from the searing summer heat. This photograph, c. 1890, was probably taken in late spring as the fringe-tree (known locally as grancy gray-beard), located in the upper-right corner of the image, is in full-bloom. (Courtesy of Georgia Department of Archives and History.)

CATOOSA SPRINGS,

THE WONDERFUL FOUNTAINS OF HEALTH AND PLEASURE,

.The Brightest Spot in the Sunny South,

Are located in the PIEDMONT REGION OF GEORGIA, twenty-five miles south-east of Chattanooga, Tenn., and within two miles of the Western & Atlantic Railroad. These Springs, fifty-two in number, embrace **every variety of Mineral Water** found in the famous mountains of Virginia—White, Red, and Black Sulphur, Alleghany, All-Healing and Chalybeate, Magnetism, Soda, and Iodine ; as also the waters characterizing the Montvale Springs of Tennessee, and Indian Springs of Georgia ; all of which are to be found here in abundance, within the compass of this " Magic Vale." affording a certain cure for Dyspepsia, Rheumatism, Gout, Liver-complaints, Scrofula, all kinds of Cutaneous Affections, and, in fact, every disease that human flesh is heir to.

This advertisement for Catoosa Springs appeared in the book *The Mineral Springs of the United States*, published in 1874. According to remarks by the book's author, Dr. George Walton, "there are very many springs at this point, all rising within the space of two acres. They were very much resorted to before the war, but the buildings subsequently needed repair. They are, however, open for visitors, and are being improved."

The waters of Catoosa Springs have been prized for centuries. The Cherokees coveted the springs and covered them from the early white settlers. By 1850, Catoosa Springs had become known throughout the South for its many unique and healthful waters. At that time, there were more than 52 visible springs on the site. It was not unusual, as it still is today, to find springs only a few feet apart with distinctly different properties. By the 1900s, the resort there was capable of accommodating more than 600 guests, and waters from the springs were being shipped to all parts of the United States. This is a *c.* 1913 photograph.(Courtesy of Georgia Department of Archives and History.)

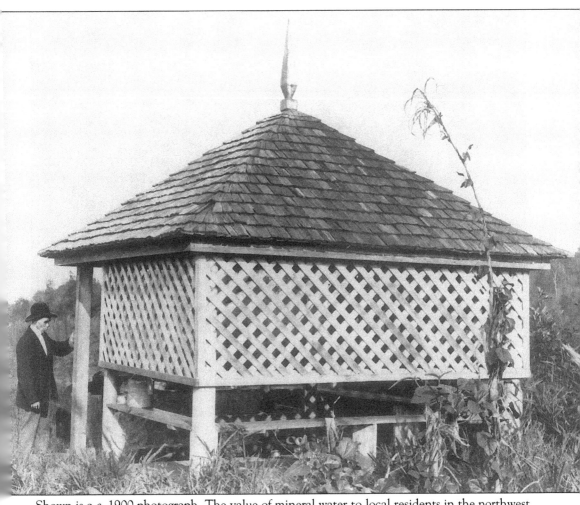

Shown is a *c.* 1900 photograph. The value of mineral water to local residents in the northwest Georgia mountains is reflected in the elaborate gazebos or "water-sheds" used to cover the spring openings. Many were outfitted with concrete basins. Later, wire mesh screens were installed that filtered out unwanted debris. The Trenton Mineral Spring in Dade County featured diagonal lattice work, a shake roof, wooden benches, and several gourd dippers for all of the partakers. (Courtesy of Georgia Department of Archives and History.)

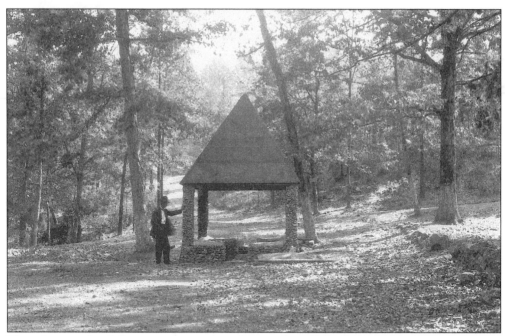

This photograph of the mineral spring at Catlett Gap, several miles east of Lafayette, was taken on October 25, 1913. The gazebo covering the spring was of ridge-rock construction and featured a highly pitched roof. (Courtesy of Georgia Department of Archives and History.)

The custom of drinking mineral water is a universal one and can be traced back to the ancient Romans who were no doubt familiar with the medicinal properties of various spring waters. In the United States, antebellum Southerners developed the annual ritual of "taking the springs tour," which involved visiting as many mineral springs and health resorts as possible during the warm summer months. Here, a local resident stops to enjoy the cooling waters of Satterfield Springs about a mile northeast of Cartersville in Bartow County, c. 1915. (Courtesy of Georgia Department of Archives and History.)

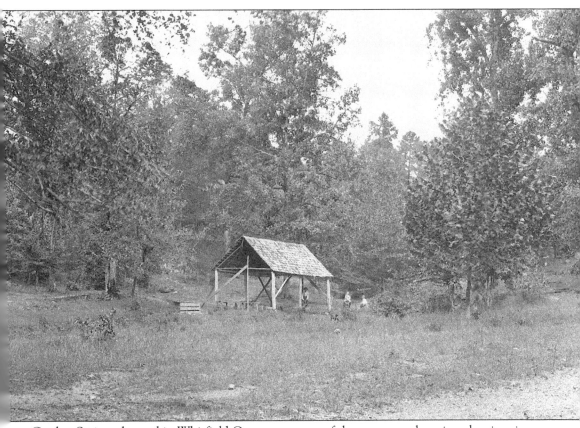

Gordon Springs, located in Whitfield County, was one of the more popular mineral springs in the area and drew the attention of George White, whose *White's Historical Collections*, published in 1854, devotes numerous pages to northwest Georgia. About Gordon Springs, White wrote: "The Medicinal Springs, owned by the Gordons, are situated at the base of Taylor's Ridge. There are twenty springs within the space of half a mile; but the main springs are twelve in number, on a beautiful eminence of Taylor's Ridge." The photograph shown was taken c. 1919. (Courtesy of Georgia Department of Archives and History.)

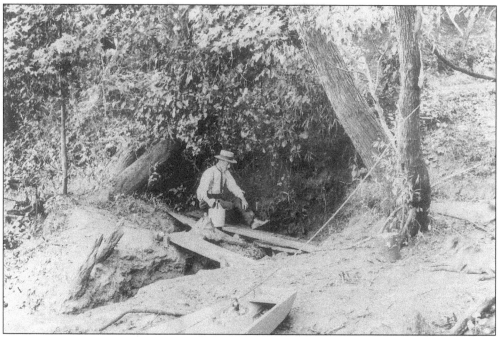

When mineral springs were located on steep slopes, more creative methods of hauling the water to and from the site had to be concocted. At Harbour Springs in Floyd County, a wooden trough was used to skid the ceramic jugs up and down the worn hillside. This is a c. 1916 photograph. (Courtesy of Georgia Department of Archives and History.)

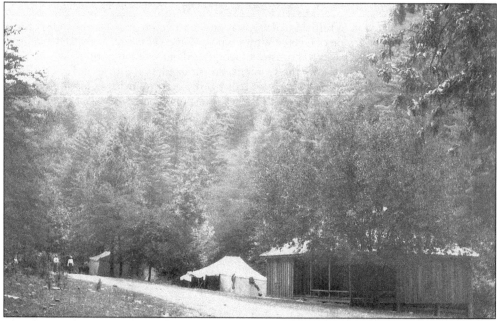

Cohutta Springs saw a rebirth in popularity during the late 19th century, and several new buildings, including a large hotel, were erected to accommodate the increasing demand. When cabin space was not available, guests could pitch canvas tents, as seen in this 1919 photograph. (Courtesy of Georgia Department of Archives and History.)

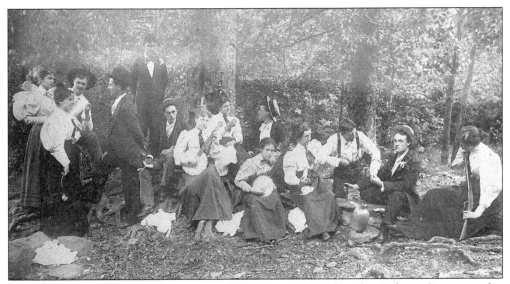

On late evenings during hot summer months, young people gathered at Cohutta Springs to play musical instruments and sometimes to dance or sing. Shown in this *c.* 1885 photograph, from left to right, are the following: Hattie Thomas, Mary McAfee, Jim Huff, Will Prater, Julian McCamy, John Thomas, Ruth Allen, Syylla Thomas, an unidentified individual, Dot McCamy, Annie Pruden, Mark Senter, Will Allen, and Nell Moore. (Courtesy of Georgia Department of Archives and History.)

Two men relax under the shade of a large oak tree at Carters Mineral Springs, *c.* 1915. The location of the spring is uncertain, but it was probably on the original Carter family estate that was partly submerged by the building of Carters Dam along the border of Murray and Gilmer Counties. Completed in 1977, Carters Dam was the inspiration for James Dickey's novel *Deliverance*, which was made into a major motion picture. (Courtesy of Georgia Department of Archives and History.)

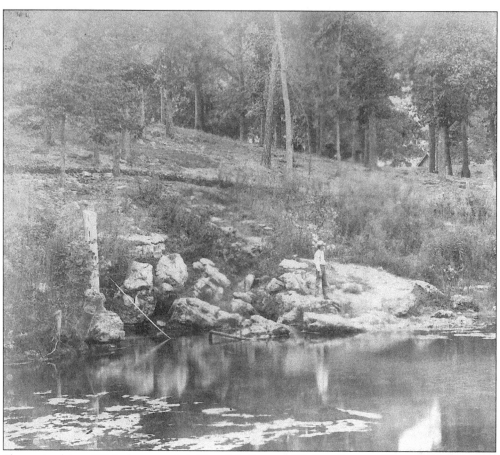

Shown in this *c.* 1916 photograph is Crawfish Springs, Walker County. The area surrounding Crawfish Springs is rich in history, being originally a Cherokee settlement and later the site of an important Civil War battle. In 1820, Crawfish Springs was made the site of the principal Cherokee courthouse, due largely to its close proximity to the Moravian Mission at Brainerd, Tennessee. An early map of the area included in the 1838 Cherokee Land Lottery contains the words "Crawfish C.H." and "Big Spring." (Courtesy of Georgia Department of Archives and History.)

Log Dam at Dew's Pond, shown c. 1925, is one of the earliest freshwater impoundments in northwest Georgia. The lake's namesake is William Francis Dew Sr., who built the dam in 1916 about 7 miles east of Calhoun. Dew's Pond is fed by Big Spring, which is also a source for commercially bottled spring water. (Courtesy of Georgia Department of Archives and History.)

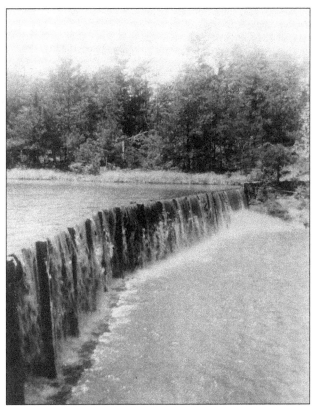

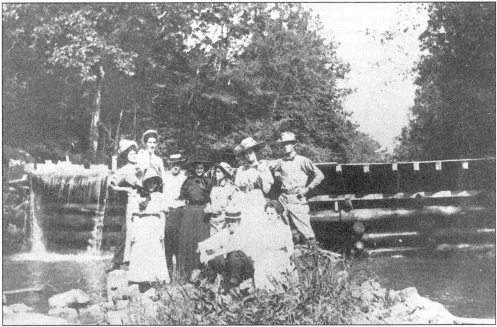

Located near the foot of Horn Mountain in Gordon County, this artesian well was a favorite picnic spot for residents of Sugar Valley during the early 1900s, when the photograph was apparently taken. (Courtesy of Georgia Department of Archives and History.)

This *c.* 1915 photograph shows Freeman Spring at an unknown location in Gordon County. (Courtesy of Georgia Department of Archives and History.)

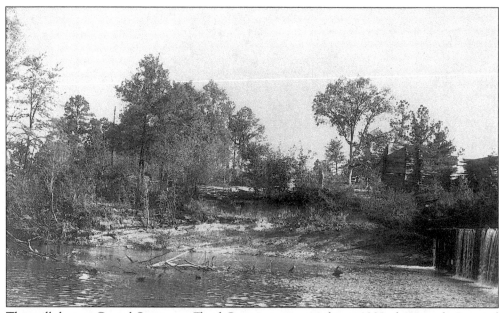

The mill dam at Crystal Springs in Floyd County is seen in this *c.* 1937 photograph. Located on the old Summerville Road, Crystal Springs was also home to a saw and gristmill operation during the early part of the 20th century. (Courtesy of Georgia Department of Archives and History.)

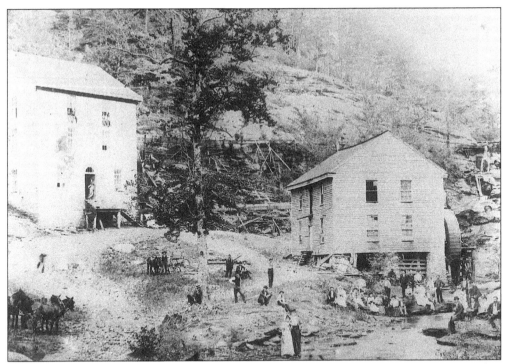

Shown is the grain storage mill, gristmill, and wool carding mill, c. 1905, built by Elias Dorsey Hightower after 1850. Hightower's milling operations were below Hightower Falls, a favorite gathering spot for Polk County residents. (Courtesy of Georgia Department of Archives and History.)

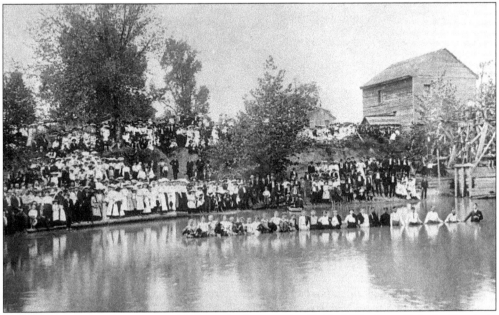

A large community baptism, c. 1900, took place at the Keith Mill along Cohulla Creek in Whitfield County. Note the ladies' large hats and white dresses and the dark suits of the men folk. (Courtesy of Whitfield-Murray Historical Society.)

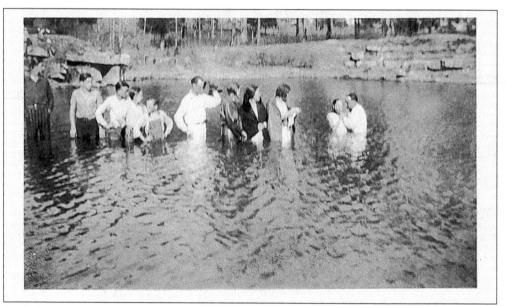

By the 1940s, "deep-water" baptisms were less frequent, and spectators were generally limited to immediate friends and family. These individuals belong to the Westside Baptist Church in Catoosa County, which was in close proximity to West Chickamauga Creek, where their photograph was taken in 1943. (Courtesy of June Edmondson.)

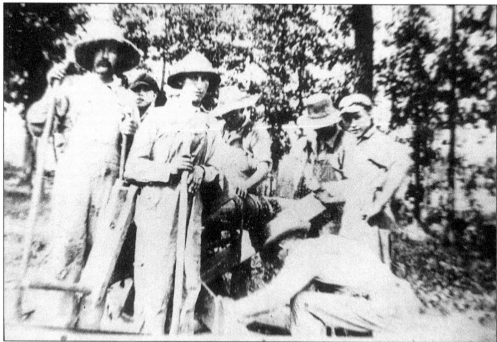

Workmen pause for a photograph, c. 1920, as the project foreman inspects the object of their labor—a well shaft for the New Hope Church in Tunnel Hill. Wells were a necessity for most northwest Georgia dwellings, providing a year-round source of good, clean water. Poorly dug wells might, however, became contaminated and were often the source of serious illnesses among local residents. (Courtesy of Bradley Putnam.)

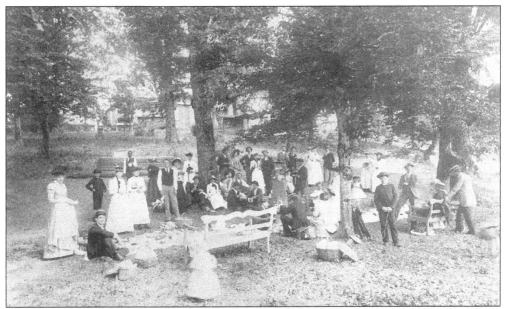

Pictured is a picnic on the grounds of Barnsley Gardens, c. 1890. Barnsley Gardens was the realized dream of Sir Godfrey Barnsley, a native of Derbyshire, England, who made his fortune in the cotton trade prior to the Civil War. Believing the air and water more healthful in the northwest Georgia mountains than in Savannah, Barnsley moved his family there and began building his showplace estate—an Italianate-style villa and surrounding gardens based on the designs of landscape architect Andrew Jackson Downing. (Courtesy of Georgia Department of Archives and History.)

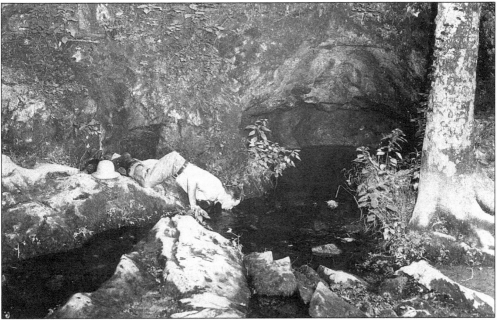

Freeman's Spring, a picturesque site located just off Highway #2 in Whitfield County, is typical of the many natural springs that abound in the northwest Georgia mountains. (Courtesy of U.S. Forest Service, Armuchee Ranger District.)

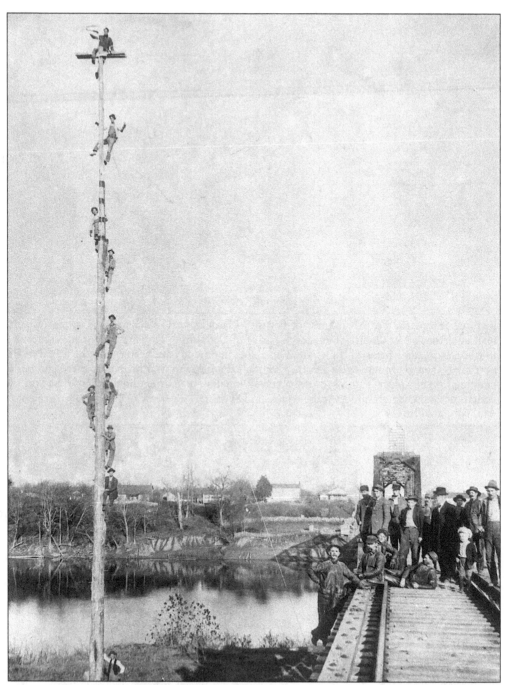

The railroad has had a profound and lasting effect on northwest Georgia. Sherman and his scorched-earth military campaign followed the existing rail line to Atlanta, destroying villages and lives along the way. Several rail lines were added during the 20th century, requiring the spanning of the area's largest rivers. Posing for this photograph are workers completing a railroad bridge over the Coosawattee River in Gordon County sometime during the early 1900s. Note the nine men atop the tall pole on the left. (Courtesy of Georgia Department of Archives and History.)

Three

MINING THE MOUNTAINS

While agriculture certainly had an important effect on the mountains and valleys of northwest Georgia, industry also left its mark on the area. Iron forges and furnaces were among the earliest industries to locate here, and collectively, they had a tremendous impact on the mountain landscape.

Among the first iron operations to operate in northwest Georgia was the Stamp Creek Furnace, erected in Bartow County in 1837 by Moses and Aaron Stroup. Others soon followed, making the area around Cartersville a major iron-producing center. Of the four furnaces erected along the Etowah River, the largest, the Etowah Furnace, employed more than 500 hands at peak production during the 1850s.

Nineteenth-century iron manufacturing required vast quantities of natural resources, all of which could be readily found in the northwest Georgia mountains, including an unlimited supply of hardwood trees. The trees were needed for the production of charcoal, the only fuel hot enough to melt the various ores used in the iron-making process. Because the mountains of northwest Georgia possessed large stands of mature oak, hickory, beech, and maple, not to mention an abundant water supply, it became a prime location for the 19th-century iron master.

During the antebellum period, iron manufacturing involved two distinct operations: blast furnaces and bloomery forges. One of the earlier blast furnaces was erected before the Civil War by Doah Edmondson in Walker County near the foot of John's Mountain. This furnace, which took two years to complete, was 20 feet by 20 feet square at its base and more than 20 feet high. The much more numerous and smaller bloomery forges also used charcoal for fuel, collectively using considerable amounts of timber. Most bloomery forges in the northwest Georgia mountains, such as the one operating on the Conasauga River in Murray County, produced what was then known as "hollow-ware," that is, kettles, pots, and pans, as well as stove plates, wrought-iron bars for nails, tools, wagon rims, mill gears, and plow points.

By the 1850s, the iron industry was having a noticeable effect on the mountain landscape. Clear-cutting of timber left surrounding hillsides devoid of vegetation and topsoil, making them

less desirable for other agricultural pursuits. The continued use of specific sites for charcoal production drastically decreased soil fertility, resulting in sterile patches of ground that, for decades, supported little or no plant life. Of course, there were numerous environmental effects resulting from iron production. Most furnaces were nearly always located near creeks and rivers since a great deal of water was needed to operate the furnace. In order to direct the greatest volume of water into the furnace operations, small dams were constructed next to the forge, resulting in the flooding of the surrounding countryside.

The environmental impact of the iron industry was not only limited to charcoal production, the building of dams, or the general forge operations. There was also the clearing of roads for employee housing, especially at the largest facilities, such as the Etna Furnace in Polk County.

By far the greatest environment impact from iron ore mining came after the first introduction of steam shovels to the industry, which allowed for the excavation of enormous quantities of earth at each mine site. This new technology was used widely in northwest Georgia, from Sugar Valley to Cartersville. As a result, the scale of mining expanded exponentially after the turn of the 20th century and left deep and lasting scars upon the mountain landscape.

Of course, iron ore was only one of a dozen or so minerals excavated in northwest Georgia during the 19th and 20th centuries. Large pockets of bauxite, manganese, and talc were also recovered, and mine sites from those excavations are still visible today.

For the first three decades of the 20th century, numerous state geologists searched the mountains for new pockets of ores, photographing potential mine sites, mineral springs, and other sites of interest as they explored the rural countryside. One of the first to systematically do this was state geologist S.W. McCallie. His photographs are among the most unique in this entire volume and are of considerable historical interest.

With the exception of talc mining, the mining of minerals in northwest Georgia was all but over by the end of the 1930s. Seven decades of mineral excavation had completely exhausted most mine sites, forcing industrialists to look elsewhere for their raw materials. Today, the mining of the mountains is a little known chapter in the history of northwest Georgia and is, in many ways, illuminated for the first time in *The Land of Ridge and Valley*.

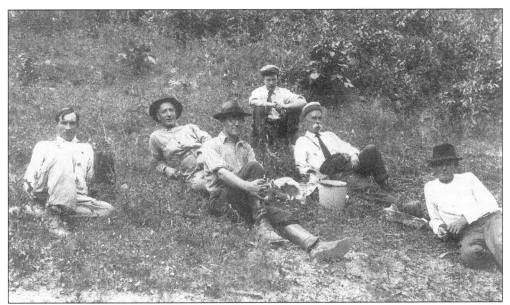

Here is a rare photo of a geological survey party at Doogan Mountain near Cisco, probably taken by state geologist S.W. McCallie around 1913. Pictured, from left to right, are W.W. Silver of Cisco; P.J. Harkins of the Southern Mining Corporation, Birmingham, Alabama; Professor Nelson C. Dale of Hamilton County, New York; an unidentified driver; E.J. Locke of the Southern Mining Corporation; and W.M. Graham of Eton. (Courtesy Georgia Department of Archives and History.)

Taken by Georgia's official state geologist in 1919, this photograph documents an important iron-ore deposit on the farm of Sam Hickey, about 2 1/2 miles southeast of Crandall in Murray County. Note the stone wall in front of the Hickey home and the large stand of burley tobacco above the Model-T Ford. (Courtesy Georgia Department of Archives and History.)

"Spring Pit" was the local name of this talc mine entrance owned by the Georgia Talc Company in Chatsworth in Murray County. The photograph was taken on June 3, 1935. (Courtesy of Georgia Department of Archives and History.)

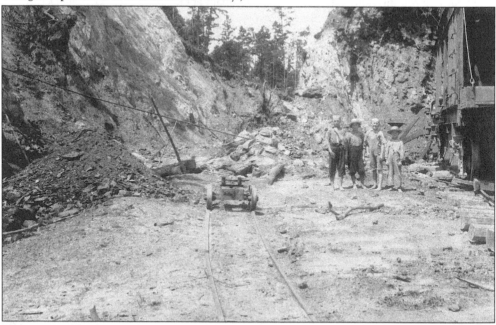

Iron ore sites like this one were scattered across northwest Georgia during the first three decades of the 20th century, at which time more than 3 million tons of iron ore were dug from area iron pits. Child labor was sometimes used at these sites but usually for tasks such as sorting stone or driving mule teams. This is an open-cut mine operated by the Cartecay Iron Company in Gilmer County. The photograph was taken by the state geologist S.W. McCallie in July 1919. (Courtesy of Georgia Department of Archives and History.)

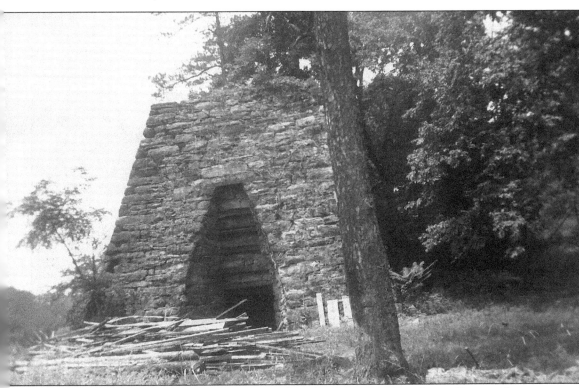

Nineteenth-century iron production was central to the economy of northwest Georgia if not the entire southern Appalachians. The iron furnace was also an important instrument of environmental change as the average facility, producing two tons of iron per day, consumed about 300 acres of mature woodland per year. Wood was needed to produce charcoal, the only substance that would burn hot enough to fully process the ore. The Cooper Furnace, one of the first in the area, was established by Mark Cooper near Etowah in Bartow County, and remains one of the few visible signs of a once vital industry. (Courtesy Georgia Department of Archives and History.)

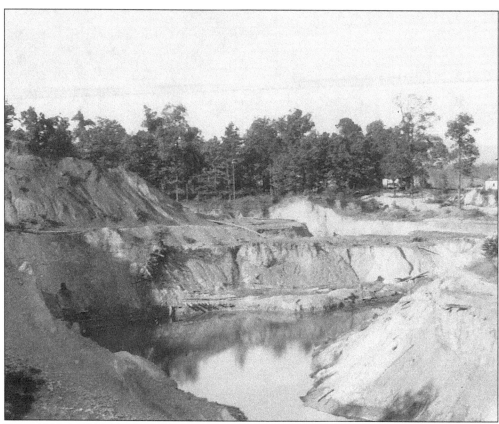

From 1918 to 1922, the LaFollette Coal and Iron Company of LaFollette, Tennessee, owned more than a 1,000 acres of land in the northern end of Gordon County. During this period, the company intensively mined an area near the town of Sugar Valley, including the Old North Hill Open-Cut, the subject of this 1919 photograph. From its Sugar Valley operations, company records reported that 40,000 tons of iron ore were excavated during this four-year period. An inventory of its on-site holdings included 30 tenant houses, 1 boarding house, 1 rooming house, 40 dump cars, 4 Dinkey steam-engines, 1 50-ton locomotive, 3 steam shovels, 2 miles of narrow gauge railroad track, 4 2-log washers, and 2 picking belts. Today, the careful observer can still see the contour changes caused by this formidable earth-moving equipment. (Courtesy of Georgia Department of Archives and History.)

By 1920, the LaFollette Coal and Iron Company owned more than 1,000 acres of land in the 25th and 26th districts of Gordon County, about 2 miles west of Sugar Valley. The first mining on the property began in 1912 by a Birmingham company and was worked by the LaFollette Company between 1918 and 1922. This sketch map of the company's mining activities shows the major cuts where ore was taken and the road and rail lines used to haul the ore to its shipping point on the Southern Railroad line. (Courtesy of Georgia Department of Archives and History.)

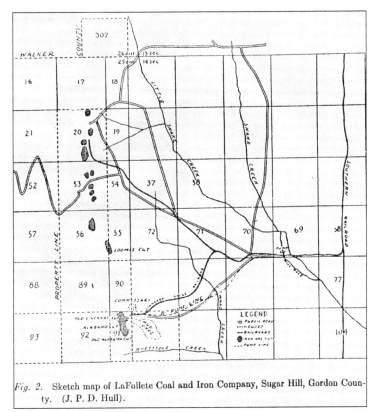

Fig. 2. Sketch map of LaFollete Coal and Iron Company, Sugar Hill, Gordon County. (J. P. D. Hull).

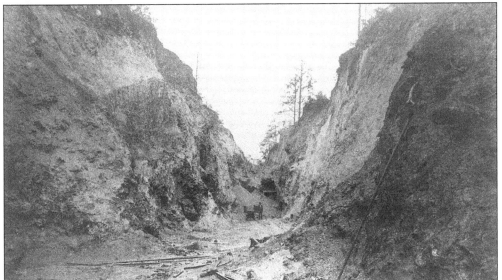

Emerson, in southern Bartow County, supplied a considerable amount of iron ore and manganese to regional furnaces during the late 19th and early 20th centuries. This excavation, known as the Wheeler Bank, was part of the Tennessee Coal, Iron and Railroad Company's 1,500-acre holdings that was leased at various times to other mining companies. Much of the ore was loaded by hand and then shipped to LaFollette, Tennessee by rail car. (Courtesy of Georgia Department of Archives and History.)

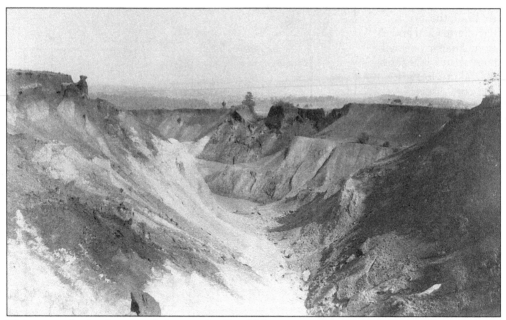

This atmospheric photograph depicts the Reed Mine, an open-pit iron ore mine located about 3 miles north of Cedartown in Polk County. According to the *Geological Survey of Georgia*, the mine was later leased by the Rock Run Furnace Company in 1920, producing a large amount of ore. The original mining area exceeded more than 10 acres and yielded more than 300,000 tons of ore. (Courtesy of Georgia Department of Archives and History.)

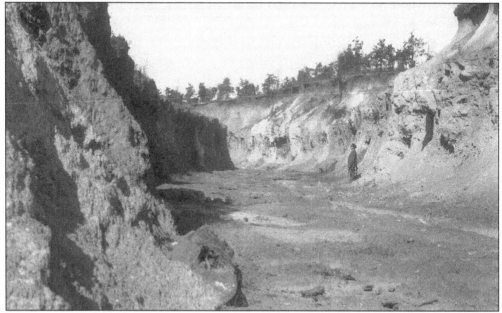

Iron ore was heavily mined in Polk County, which could claim some of the largest mines in the state. This ore bank was worked by the Wookstock Operating Corporation, who leased the property from the Woodstock Iron and Steel Corporation of Anniston, Alabama. This photograph was taken approximately 1 mile west of Cedartown, on October 16, 1913, by S.W. McCallie. (Courtesy of Georgia Department of Archives and History.)

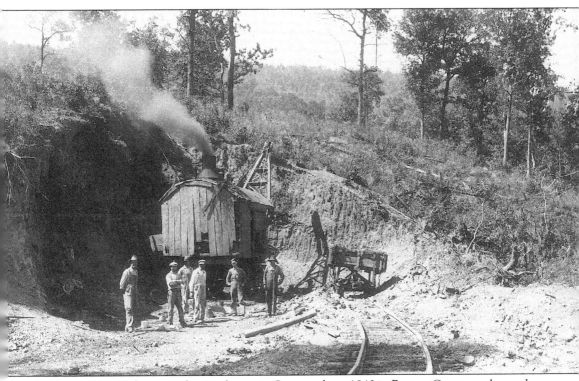

Iron ore mining and iron production began in Georgia about 1840 in Bartow County and spread northward. Sherman's march through Georgia left most of the major furnaces in ruins but smaller forges and bloomeries were soon erected across the northwest Georgia mountains. The LaFollette Coal and Iron Company heavily mined an area west of Sugar Valley and this cut, excavated by steam shovel, was thought to contain considerable ore. The photograph was taken *c.* 1920. (Courtesy of Georgia Department of Archives and History.)

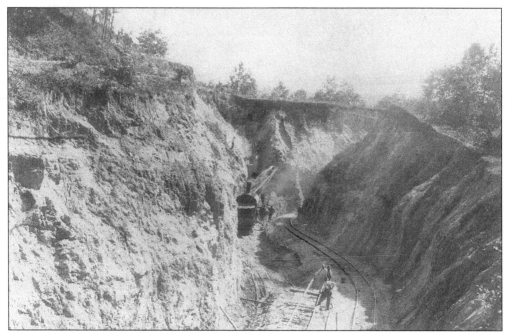

The Wheeler Iron-ore Bank was located about 1 mile south of Emerson on the Western and Atlantic Railroad. Most of the ore in the area was mined prior to 1900, but the Wheeler "cut" remained in operation until well after 1913, when this photograph was taken. (Courtesy of Georgia Department of Archives and History.)

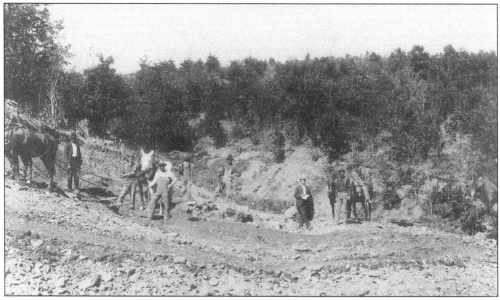

This *c.* 1905 picture shows strip-mining for iron ore atop Pigeon Mountain, near Estelle in Walker County. This surface operation was being carried out by the Southern Steel Company who leased the property from the owners, the Kensington Iron & Coal Company. Today this site is within the boundaries of the Pigeon Mountain Wildlife Management Area, a popular recreation area owned and managed by the state.(Courtesy of Georgia Department of Archives and History.)

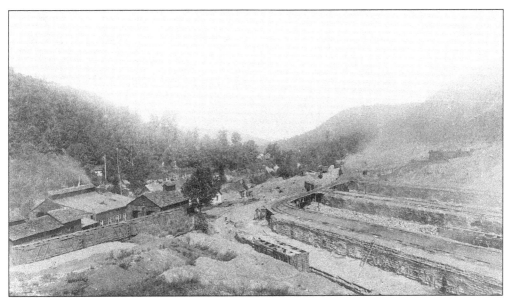

Pictured are coke ovens at the Georgia Iron and Coal Company at Cole City in Dade County. In the 19th century, the Georgia Iron and Coal Company was owned by governor Joseph E. Brown, who used convict labor in his northwest Georgia mines. This photograph was taken by the state geologist, probably around 1919. (Courtesy of Georgia Department of Archives and History.)

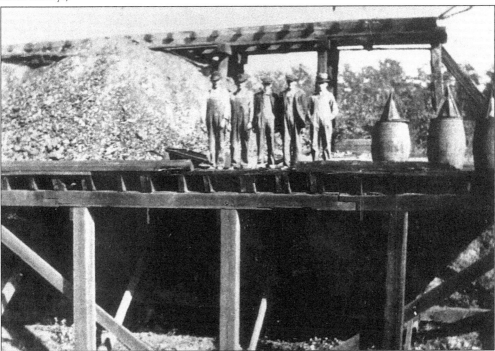

This coal chute and loading platform was located along the railroad line in Varnell, Whitfield County. Coal was essential to the heating of homes and businesses during the early part of the 20th century, and so there was always great demand for the black gold during fall and winter months. (Courtesy of Whitfield-Murray Historical Society.)

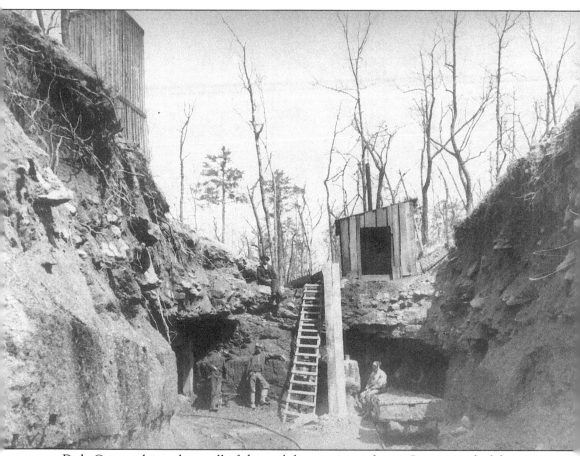

Dade County claims almost all of the coal deposits in northwest Georgia, and of these, most were mined prior to World War II. Coal mining can have profound environmental impact on mountain streams as tailings from mine sites are highly acidic. In fact, several of the streams in the Little River Canyon National Preserve in northeast Alabama were effected by Dade County coal mines and remediation of those streams was recommended before the area achieved National Preserve status. This photograph is of the entrance to a mine operated by the Raccoon Coal Company sometime before 1920. (Courtesy of Georgia Department of Archives and History.)

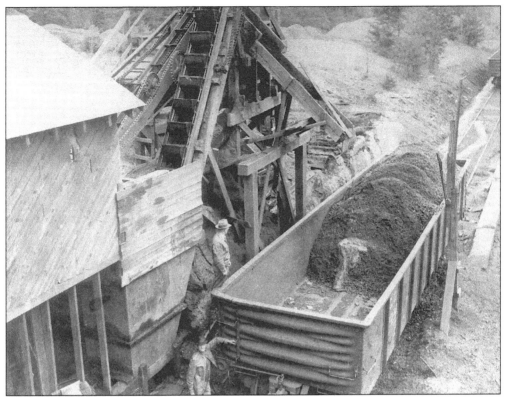

This *c.* 1943 photograph illustrates the loading of fine-grade coal for steam plant use. These two men, W.A. Murray and Garland Peyton, were officials of Durham Coal, Inc., of Pittsburg, Georgia, and are inspecting the company's tipple and loading operations. (Courtesy of Georgia Department of Archives and History.)

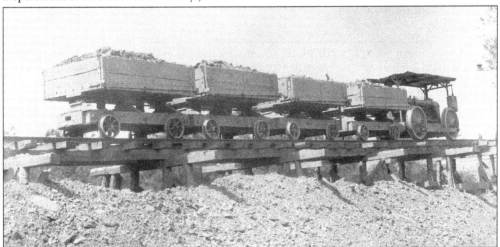

This *c.* 1930 photograph shows cars loaded with talc at the Southern Talc Mill in Chatsworth, Murray County. According to Joe Henry, who as a young boy bagged dust at the mill, the talc industry was dangerous, especially for those sawing talc crayons. In fact, his father, George Henry, who worked at the mill for more than 20 years, contracted emphysema as a result of his continuous exposure to the dust. (Courtesy of Georgia Department of Archives and History.)

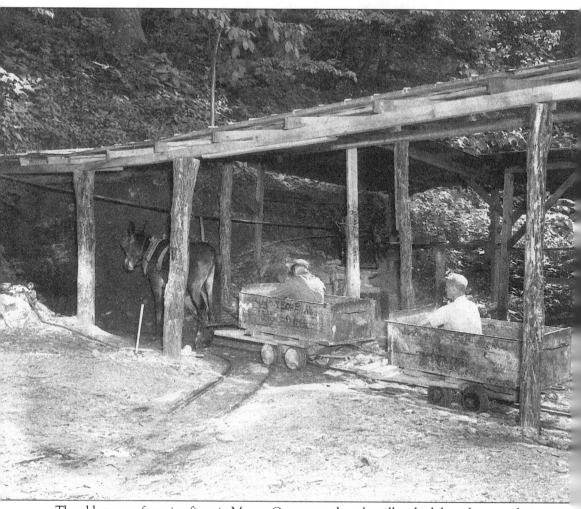

The oldest manufacturing firms in Murray County are the talc mills, which have been producing talc since 1872 when W.C. Tilton first began operations near Chatsworth. Murray County talc, a form of magnesium silicate, was used in the making of paint, rubber, roofing material, and insecticides. Since the industry's beginnings, more than 4 million tons of talc have been excavated from the area. This photograph, taken in June 1946, shows the main entrance to the mine operated by the Cohutta Talc Company during the 1940s. The mule was used to tram empty cars into the mine. After loading, the cars rolled from the mine with the aid of gravity. (Courtesy of Georgia Department of Archives and History.)

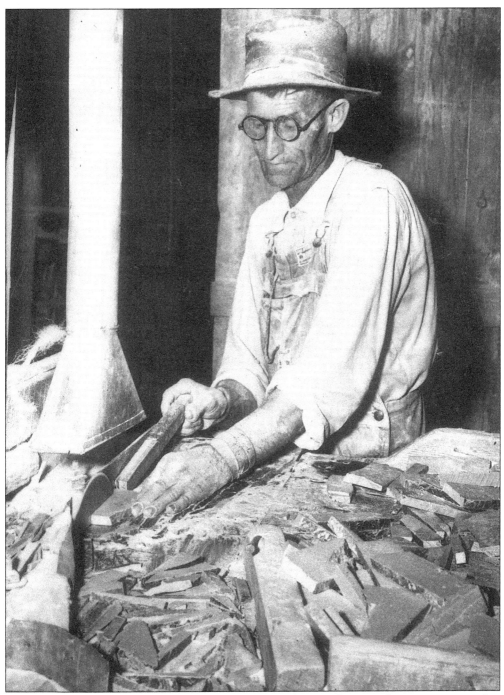

A veteran worker at the Cohutta Talc Company in Chatsworth saws talc into crayons with a high speed saw in this c. 1944 photograph. The production of talc crayons was important to the war effort, as talc is the only substance that would permanently mark steel. Ship building firms relied heavily on talc crayons during WW II and the Cohutta Talc Company remained one of the nation's largest suppliers. Note the vented pipe, part of an elaborate dust collection system used throughout the plant. (Courtesy of Georgia Department of Archives and History.)

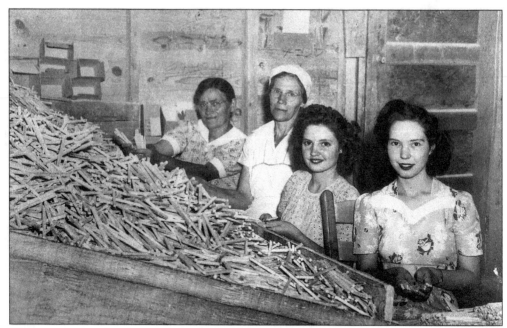

Women were employed extensively in the talc industry, especially during WW II when labor shortages were at their peak. Here, women, both young and old, sort crayons before placing them into boxes that were then shipped by rail to major distribution points. This photograph was taken in 1944 by M.H. Berry of Wesleyan College in Macon, Georgia. (Courtesy of Georgia Department of Archives and History.)

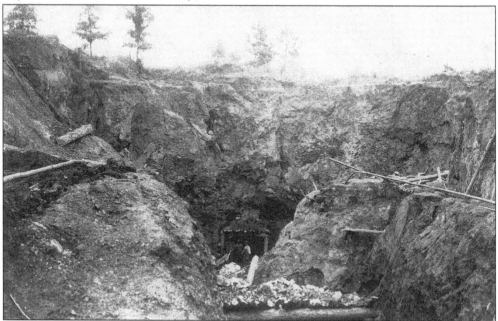

This photograph, taken by the state geologist S.W. McCallie on June 15, 1915, shows an open-pit manganese mine on the property of Dr. Vaughan, Bartow County. Manganese was historically used as an alloy in making aluminum and copper metals or as a dye and paint additive. (Courtesy of Georgia Department of Archives and History.)

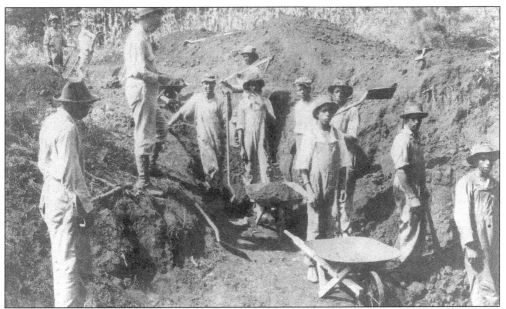

This July 23, 1918 picture shows a manganese prospect mine being dug on the property of J.R. Reeves near Cave Spring in Floyd County. Manganese is an important ore added to steel and iron to produce a very tough alloy that was extremely resistant to wear. Cash safes, torpedo and boat propeller blades, and numerous specialty wires use manganese compounds in their production. (Courtesy of Georgia Department of Archives and History.)

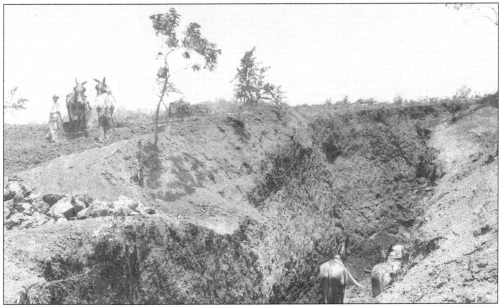

Mule-drawn metal "scrapes" were the most commonly used technology in the early mining operations of the area. The large metal blade loosened the earth and ore, which was then shoveled by hand into wagons or railroad cars. This photograph, taken July 12, 1918, is of the Samuel Lanski manganese prospect located about a mile from what was then called Varnell's Station in northern Whitfield County. (Courtesy of Georgia Department of Archives and History.)

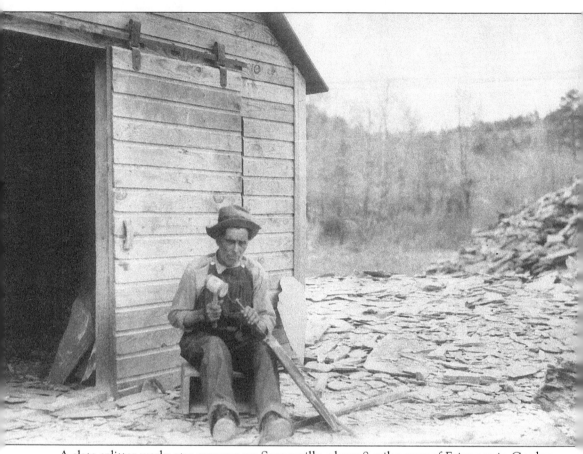

A slate splitter works at a quarry near Sonoraville, about 8 miles west of Fairmont in Gordon County, c. 1930. Slate was once a popular roofing and building material but fell out of favor during the 1930s. (Courtesy of Georgia Department of Archives and History.)

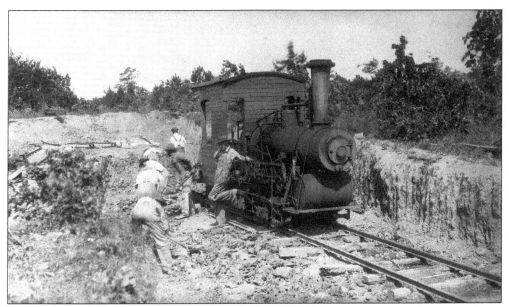

Shale was mined heavily throughout the northwest Georgia mountains as the material was used extensively in brick and tile manufacturing. "Dinkey" steam engines were frequently needed to haul the material to processing, so considerable narrow-gauge track had to be laid to each site. Here workmen repair a small section of track, c. 1935, for the Chatsworth Clay Manufacturing Company in Murray County, Georgia. (Courtesy of Georgia Department of Archives and History.)

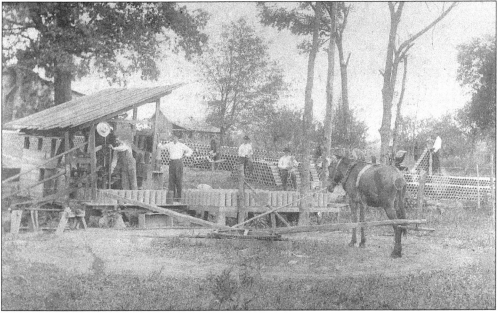

The northwest Georgia mountains are rich in natural resources, including clay chert, used to make various and sundry things such as bricks, tile, and tile piping. In this c. 1912 photograph, workers at this "one-mule" pipe mill, located along Houston Valley Road in western Whitfield County, stack rows upon rows of tile-pipe before taking them to be fired and baked at a nearby kiln. (Courtesy of Georgia Department of Archives and History.)

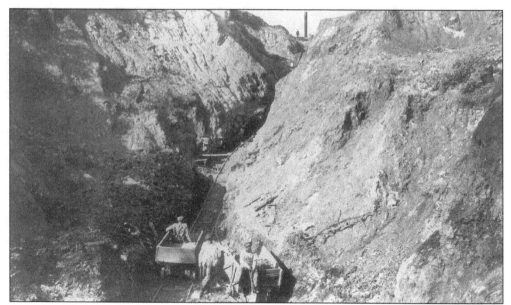

A barite mine, shown in this c. 1917 photograph, was owned by the Thompson-Weinman Company about 1 mile east of Cartersville in Bartow County. Bartow County was an important national source for barite and the Thompson-Weinman Company operated one of the largest barite grinding plants in the entire United States. (Courtesy of Georgia Department of Archives and History.)

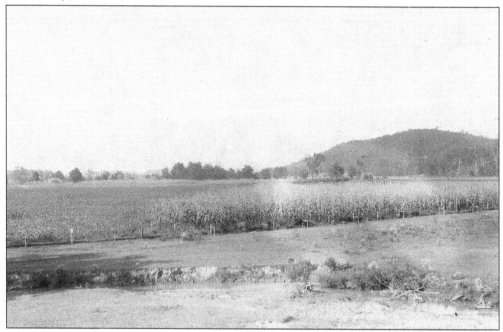

An early photograph shows Mill Creek Valley near the foot of Grassy Mountain in Murray County. The photograph was taken in 1919 by the state geologist who was documenting the presence of a small barite mine, which is barely visible beyond the cornfield. Barite, used in the manufacture of paint and rubber, was usually mined in open pits, leaving deep and lasting scars upon the landscape. (Courtesy of Georgia Department of Archives and History.)

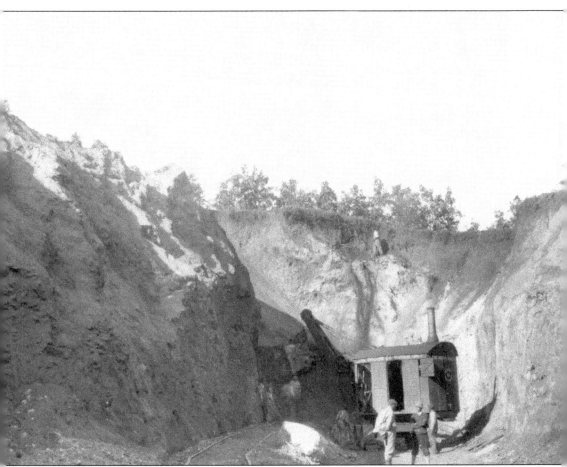

Barite, a heavy mineral that is blue or white in color, was in great demand during World War I. This c. 1916 photograph is of the Bertha Mining Company's barite mine near Cartersville in Bartow County. (Courtesy of Georgia Department of Archives and History.)

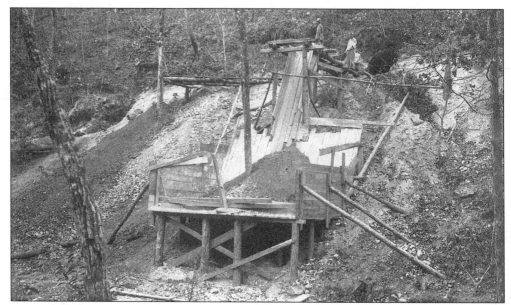

Halloysite was one of many ores excavated in northwest Georgia at the beginning of the last century. Halloysite, a type of Kaolin clay, has a number of important uses, including the making of heat-resistant ceramics and pottery. This mine was owned and operated by the American Chemical Company at an unspecified location in Chattooga County. The photograph was taken by the Georgia state geologist around 1919. (Courtesy of Georgia Department of Archives and History.)

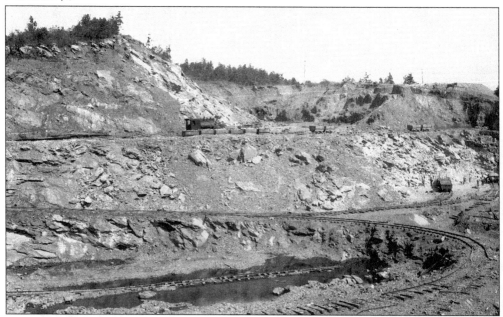

This 1913 photograph shows a limestone quarry operated by Southern State Portland Cement Company near Rockmart in Polk County. To make the cement, workers dynamited the limestone before breaking it into smaller pieces with sledgehammers. These smaller chunks were then loaded into narrow-gauge locomotives and taken to large crushers at the main plant. (Courtesy of Georgia Department of Archives and History.)

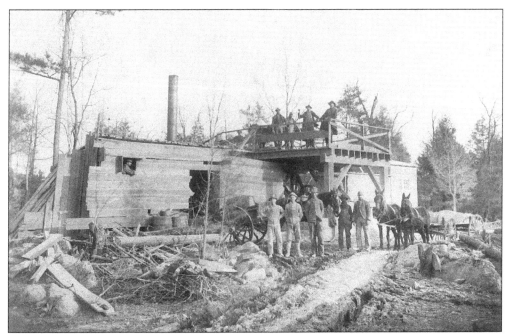

The Southern States Cement Company operated at the small hamlet of Aragon in Bartow County for 50 continuous years before being sold to the Marquette Cement Company. In this 1902 photograph, construction workers pose in front of the company's future powerhouse, which drew visitors from as far away as Europe. Employee R.H. Mintz Sr. is seen in the window at the far left. (Courtesy of Georgia Department of Archives and History.)

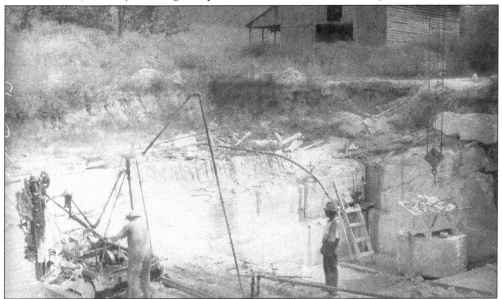

Marble quarrying, more closely associated with Tate and Marble Hill in Gilmer County, was also mined in Chattooga County, although to a much lesser degree. The largest quarry was located on the farm of E.W. Sturdivant, near the present-day James "Sloppy" Floyd State Park, and was run under the supervision of Mr. Lamb Godwin during the 1920s and early 1930s. (Courtesy of Georgia Department of Archives and History.)

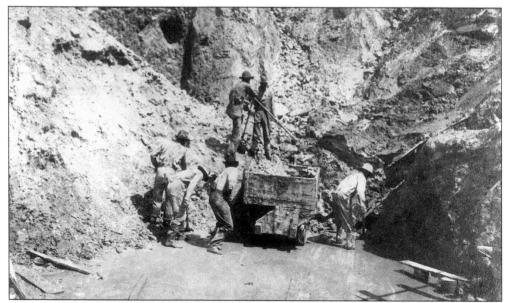

Workers load bauxite ore by hand at Hermitage in Floyd County in this *c.* 1900 photograph. Bauxite was also mined in nearby Bartow County near Kingston and Adairsville. After 1926, due partly to competition from larger Arkansas mines, bauxite mining decreased dramatically in northwest Georgia. (Courtesy of Georgia Department of Archives and History.)

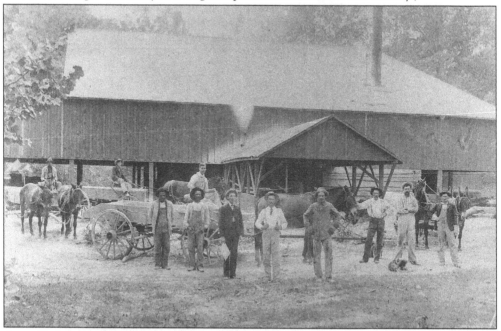

Assembled wagon teams are shown *c.* 1890 at Hermitage in Floyd County, the site of the first discovery of bauxite in North America. The ore was unloaded under the eaves of this cantilevered shed where it was allowed to dry before further processing. Bauxite, an aluminum ore, is dull in appearance and usually occurs in pea-sized lumps formed by the rapid weathering of granite rocks in warmer climates. (Courtesy of Georgia Department of Archives and History).

Four

THE FOREST FOR
THE TREES

Northwest Georgia forests are unique to the Ridge and Valley province of the southern Appalachians. Historically, these forests were comprised almost exclusively of hardwoods, with oaks and hickories being the most dominant of the tree species. Species composition varied with elevation, however, and south-facing slopes would often harbor stands of shortleaf pines. At higher elevations, chestnut trees could be found in scattered groves, at least until the 1940s when the valuable tree was exterminated by a deadly blight.

The diary of Moravian Missionaries Steiner and Gottlieb Byhan, who lived at Spring Place in Murray County, provides one of the earliest descriptions of northwest Georgia forests. "The all-purpose woods," they wrote in 1801, "are hickory, black, white, and other oak, chestnut, walnut, poplar, sourwood, and many others. In the low places are maple, beech, elm, sweetgum . . . sassafras [and] sumach."

Trees in the native hardwood forest of northwest Georgia were of exceptional size and quality, as evidenced by the comments of M.H. Bunn, who traveled through the region in 1844: "In afternoon I left Mr. Price's [home] and reached Mr. Henry's [home] higher up in Broomtown Valley in Walker County. Passed through a beautiful section of fertile land. Never saw a section more heavily timbered. Red oak, chestnut, and poplar, etc., remarkably tall and straight, stood thick, forming almost a complete shade."

The forest had not completely gone un-cut in the mountains, as lands had been cleared for agriculture since well before the 18th century. Trees in the wide river valleys were the first to see the axe, and gradually more and more timber was cleared along hillsides and more accessible slopes. Most 19th-century farmers left more than half of their farmstead in woodland as the trees also provided them with food, firewood, and forage for their ranging livestock.

By the 1870s, the forests of northwest Georgia became the target of land and mineral speculation, initiated largely by Northern industrialists seeking to acquire large tracts of unsettled lands for mining and timbering. These lands were acquired slowly, as railroad lines were needed to take full advantage of these untouched natural resources. Large-scale timbering often proceeded mining operations, as the standing trees were major obstacles to the mineral ore extraction.

Perhaps the most extensive of all logging operations in northwest Georgia were those of Conasauga Lumber Company, who owned more than 70,000 acres in Murray, Fannin, and Gilmer Counties. The company, which was based in Cincinnati, moved into the region after 1912 and logged extensively the area that is today the Cohutta Wilderness Area, as well as the northwest corner of Murray County, including the headwaters of Holly Creek.

The 1920s was the heyday of industrial logging in northwest Georgia, which involved elaborate harvesting and transport systems to get the tall timber to the local mill. Cable "skidders" were sometimes used to drag the fallen logs to the rail lines, which were loaded with a steam-powered engine and winch. From there, Shay locomotives were often used to transport the logs to the sawmill. By 1925, the Conasauga Lumber Company employed more than 700 men, making it one of the area's largest employers.

As a result of many of the environmental abuses of industrial logging, the National Forest Service was formed during the second decade of the 20th century to help acquire cut-over lands and return them to timber productivity. One of the first tracts of land bought in the area included a 23,000-acre tract purchased in 1930 from the Conasauga Lumber Company. These lands became part of the Chattahoochee National Forest, and later the Cohutta Wilderness Area, the largest protected tract of public land in the eastern United States. The Chattahoochee National Forest was officially established by a presidential proclamation on July 9, 1936, with a combined area of 1,165,000 acres.

The lands to be purchased for the Armuchee Ranger District, which lay far to the west and south of the Cohutta Mountains, were also purportedly cut-over, burned over, and of little economic value. During the 1930s, to help rejuvenate the mountain landscape, members of the Civilian Conservation Corps planted trees and built several recreation areas. Fish and game were also stocked into the National Forest, including white-tailed deer, which had been virtually eliminated from the northwest Georgia mountains by 1940. By the 1960s, land acquisition efforts in the Armuchee Ranger District had been largely suspended, leaving the total acreage at around 65,000 acres.

Despite its smaller size, the Armuchee Ranger District contains some of the largest contiguous stands of hardwoods found in the entire Ridge and Valley province of southern Appalachia. It also contains rare stands of "transmontane," or high elevation long-leaf pines. Botanist Eliza Frances Andrews was among the first to draw attention to these unusual trees and wrote about their extraordinary ability to resist fire in a 1917 article published in the *Botanical Gazette*.

Today the Chattahoochee National Forest serves as an important recreation area, attracting visitors from across the South. Efforts to protect the area from logging have been relatively successful, as 20,000 acres of the Armuchee Ranger District have been permanently taken out of the timber base.

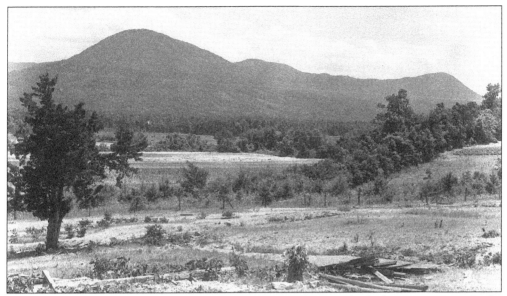

The Ridge and Valley province of the southern Appalachians is flanked on its eastern edge by the Blue Ridge Mountains. The Cohutta Mountains, in Murray County, represent the beginning of the Blue Ridge mountain chain, and they loom ominous over the valley floor. Here is Fort Mountain, c. 1946, which for centuries has served as an important lookout post, as the view to the west and north remains one of the most breathtaking in all of northwest Georgia. (Courtesy of Georgia Department of Archives and History.)

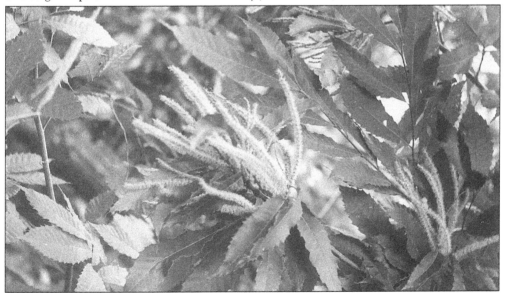

At one time, northwest Georgia could boast many large stands of American chestnuts, a tree that once covered 200 million acres of land from Maine to Georgia. A well-documented reconstruction of the 19th-century forest in the northwest Georgia mountains found chestnut tress comprising 6 percent of the area with hickories making up 10 percent of the total forest. By 1940, the chestnut blight had destroyed most of the trees in the area. Today a few blight-resistant trees in the area continue to send up shoots from still living stumps, but usually die before reaching nut-bearing size.

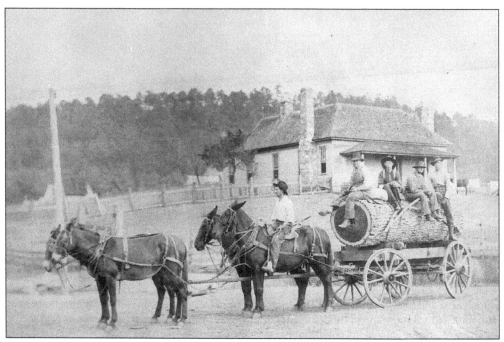

By 1905, the local market for sawtimber had developed to such a degree in northwest Georgia that exceptional trees were bought for as much as $1 per tree. Here, two mule teams and five men transport a single oak log to the sawmill. The home in the background is reported to be Mrs. Grace Boyd's, a resident of Fairmount or possibly Ranger, when this photograph was taken in 1910. W.H. McConnell is the gentleman holding the reins. (Courtesy of Georgia Department of Archives and History.)

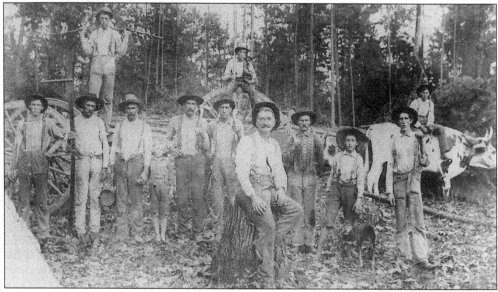

This c. 1901 photograph shows a sawmill crew on the farm of Joseph Emerson Brown, former governor and one of the largest landowners in the state. Brown's farm was located in Crane Eater on the Coosawattee River east of Calhoun in Gordon County. (Courtesy of Georgia Department of Archives and History.)

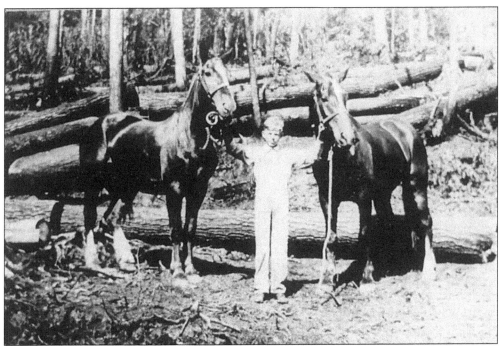

A young Walter Standridge holds the reins of two fine draft horses near the banks of the Jacks River in this c. 1923 photograph. (Courtesy of U.S. Forest Service, Cohutta Ranger District.)

Hunting dogs were invaluable companions to mountain families during the early part of the last century. These hounds belonged to Chris Standridge, photographed here at a Jacks River logging camp around 1912. (Courtesy of U.S. Forest Service, Cohutta Ranger District.)

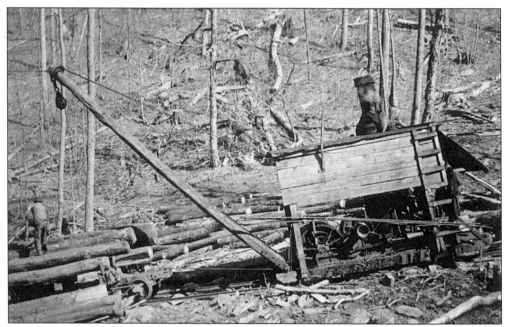

Shown is a steam-powered log loader using a spar and pulley. Two men work up front while another operates the machinery while sitting behind it. The apparatus rode on rails and could be moved to places like Sugar Cove, in Fannin County, where this photograph was taken around 1925. (Courtesy of U.S. Forest Service, Cohutta Ranger District.)

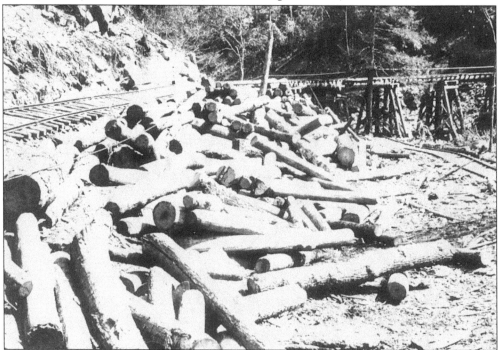

Conasauga River Lumber Company log landing at Jacks River is shown in this c. 1925 photograph. Note the pole-type railroad ties and high trestle. (Courtesy of U.S. Forest Service, Cohutta Ranger District.)

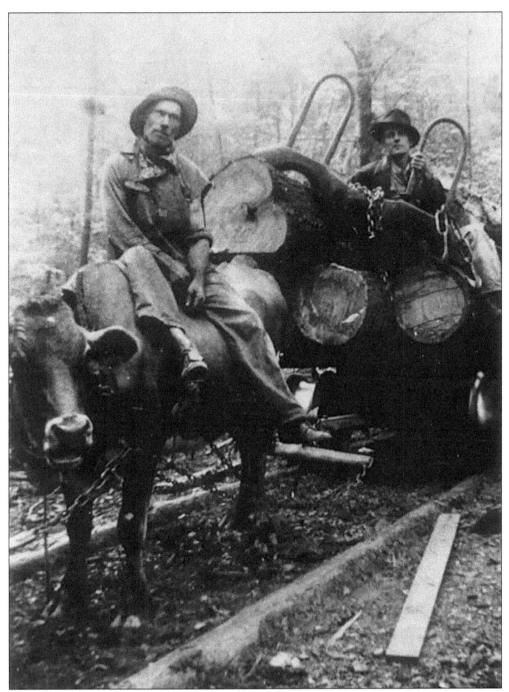

This photograph, taken on Grassy Mountain in Murray County around 1933, is a good example of "pole-car" logging, which involved the use of wooden, rather than iron, rails. Coot Barnes is riding atop the ox and Chris Standridge balances himself between the large logs. (Courtesy of U.S. Forest Service, Cohutta Ranger District.)

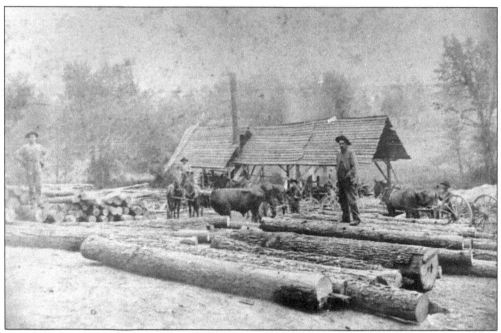

This sawmill operation was located in Tilton, at the south end of Whitfield County, along the banks of the Conasauga River. Oxen and mule teams were used to drag the logs across the landing yard to be cut into lumber. Standing on the log at right is local resident H.L. Nations, who owned the mill when this photograph was taken in the early 1900s. (Courtesy of Whitfield-Murray Historical Society.)

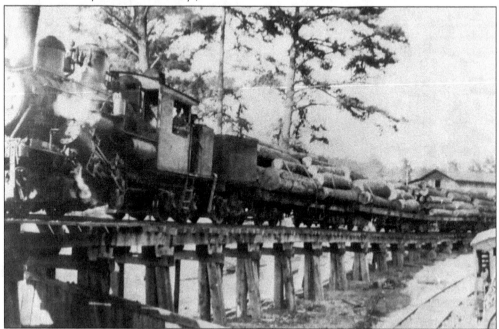

A 70-ton, Climax Locomotive hauled logs from the Cohutta Mountains to the Conasauga River Lumber Company's sawmill near the Georgia/Tennessee border. This photograph was taken c. 1924. (Courtesy of U.S. Forest Service, Cohutta Ranger District.)

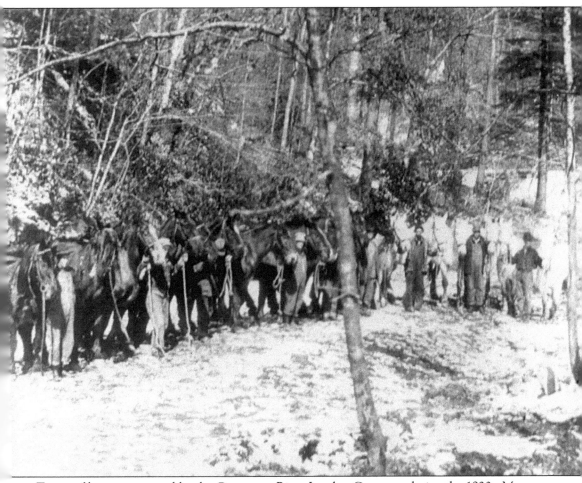

Teams of horses were used by the Conasauga River Lumber Company during the 1920s. Mose Painter, who worked as an engineer for the Conasauga River Lumber Company, recalled the importance of horses to their logging operations: "They had to use horses to haul logs in the mountains. We didn't have any trucks and mules were too dumb. You could take a mule up a corduroy road, a road made of poles to enable logs to skid easily, and if the logs started to crowd a mule, it would try to outrun the logs!" (Courtesy of U.S. Forest Service, Cohutta Ranger District.)

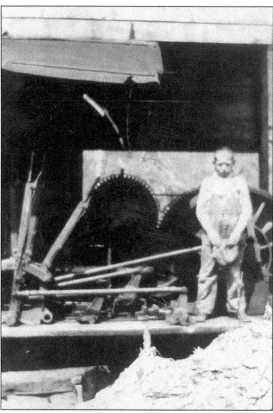

June Harden poses at a sawmill operation somewhere in the Cohutta Mountains, *c.* 1925. (Courtesy of U.S. Forest Service, Cohutta Ranger District.)

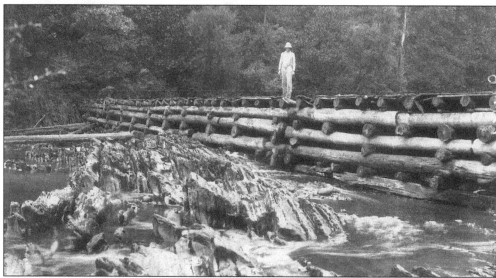

Splash dams like these were often constructed to create artificial floods that would carry away cut timber gathered from stream sides. After the dam was blown away by dynamite, the logs were floated downstream to a designated sawmill. This dam was located on Jacks River, near the junction of the Conasauga River in Murray County. The photograph was taken by S.W. McCallie, state geologist, in September 1914. (Courtesy of U.S. Forest Service, Cohutta Ranger District.)

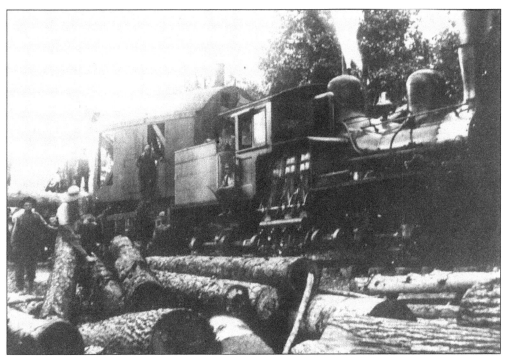

A Shay 50-ton Steam Engine pulls a Marion log loader in what is today the Cohutta Wilderness Area of the Chattahoochee National Forest. Because of the remoteness of mountain timber in northwest Georgia, the logging industry routinely used steam engines and rail lines to access the standing trees. Remnants of these rail lines can still be observed in remote sections of the Cohutta Wilderness Area. (Courtesy of U.S. Forest Service, Cohutta Ranger District.)

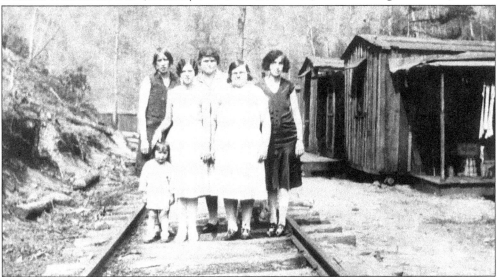

Women made important contributions to the life of the lumber camps in the mountains. These women worked as cooks for the Conasauga River Lumber Company, making large meals for the hungry men who often toiled for more than 12 hours per day. The men worked for subsistence wages, sometimes paid in script or "doogle-loo," the local term for the currency. (Courtesy of U.S. Forest Service, Cohutta Ranger District.)

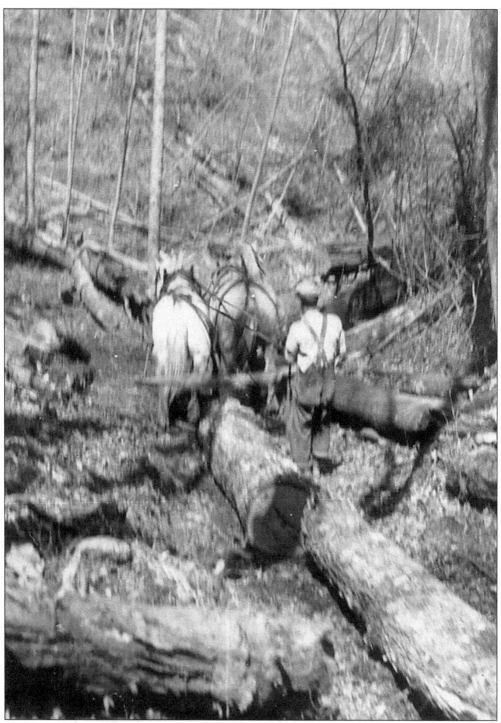

Shown here is horse logging along the Conasauga River, c. 1940. Horse logging was less environmentally destructive to the mountain landscape, as steam powered skidders dragged the heavy logs greater distances—and with much greater force—across the forest floor. (Courtesy of U.S. Forest Service, Cohutta Ranger District.)

Rail lines can be seen running through the middle of this logging camp at Horseshoe Bend, near Jacks River in Fannin County. The buildings, which were movable by rail, were used for housing and storage. The photograph was taken *c.* 1925. (Courtesy of U.S. Forest Service, Cohutta Ranger District.)

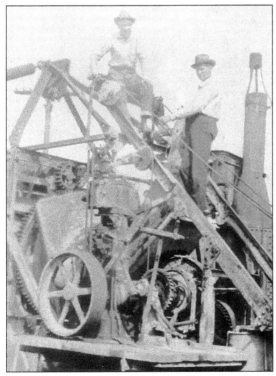

This elaborate mechanical skidder, owned by the Conasauga River Lumber Company, was moved by rail to various logging sites in the Cohutta Mountains. (Courtesy of U.S. Forest Service, Cohutta Ranger District.)

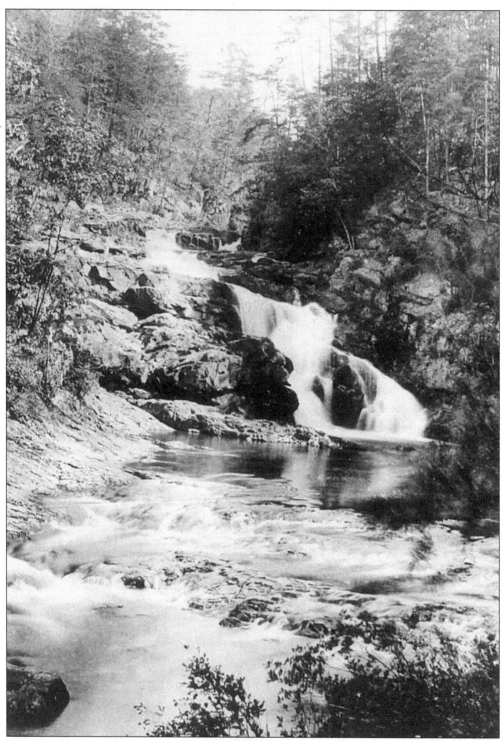

This c. 1940 photograph shows a waterfall along the Jacks River near Beech Bottoms in north Fannin County. Beech Bottoms remains a popular camping area today, due in part to its close proximity to Jacks River Falls. (Courtesy of U.S. Forest Service, Cohutta Ranger District.)

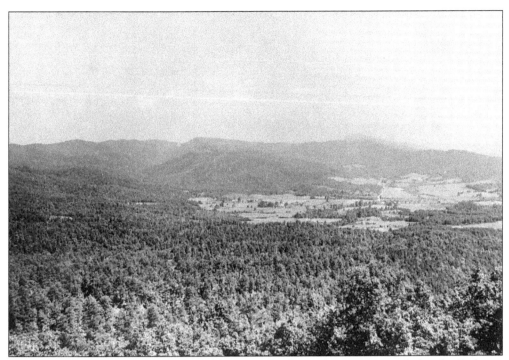

Located in the southern end of Whitfield County, Redwine Cove was named after the Redwine family who first settled the area. At the cove's eastern entrance was Cove City, a 19th-century community with a post office and several churches. The Redwine family still plays an important role in the picturesque cove that today is surrounded almost entirely by the Chattahoochee National Forest. (Courtesy of U.S. Forest Service, Armuchee Ranger District.)

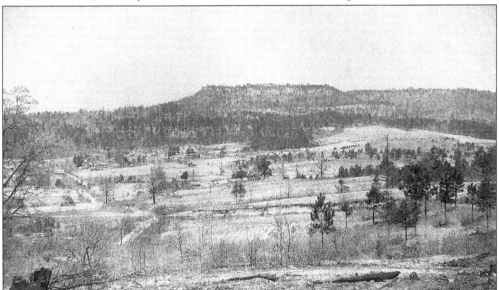

Shown is a *c.* 1937 view of Rocky Mountain looking north from Lavender Mountain. Lavender Mountain, the highest point in Floyd County, rises to 1,695 feet and provides spectacular views of the northwest Georgia mountains. (Courtesy of Georgia Department of Archives and History.)

The Chattahoochee National Forest was established by a presidential proclamation on July 9, 1936, and included lands in Dawson, Fannin, Gilmer, Habersham, Lumpkin, Murray, Rabun, Towns, Union, and White Counties. A year later, the National Forest Reservation Commission approved the addition of the Armuchee Purchase Unit, which targeted the acquisition of 250,000 acres of forest lands in Chattooga, Dade, and Walker Counties. By 1940, only 48,000 acres had been actually acquired by the federal government, which included additional timberlands in Whitfield, Gordon, Floyd, and Catoosa Counties. Today the Armuchee Ranger District comprises 66,000 acres of forest lands in northwest Georgia. Shown is a c. 1940 photograph. (Courtesy of U.S. Forest Service, Armuchee Ranger District.)

This photo, taken from the southern slope of Chestnut Mountain, along a former fire tower road and looking west into Walker County, shows a striking view of Turkey Creek Valley, which today lies in a proposed National Recreation Area of the Chattahoochee National Forest. In the distance is Horn Mountain, and along the farthest horizon, John's Mountain. (Courtesy of U.S. Forest Service, Armuchee Ranger District.)

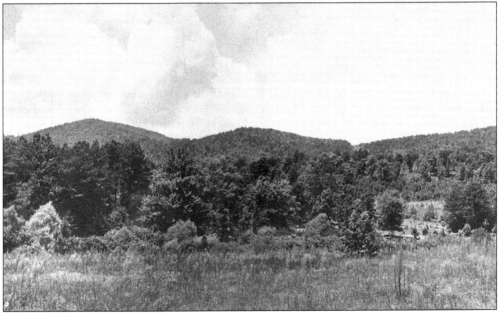

This view of Rocky Face Mountain with Dug Gap to the right, as seen from the beginning of Dug Gap Road near Dalton, was taken c. 1940. (Courtesy of U.S. Forest Service, Armuchee Ranger District.)

This exceptional photograph, taken in 1940, shows old-growth short-leaf pine trees in the Armuchee Ranger District of the Chattahoochee National Forest. The Armuchee Ranger District, which encompasses more than 66,000 acres of public land in northwest Georgia, was the last purchase area added to the national forest in the state. Mrs. Beaulah Taylor of Summerville, the so-called "Mother of the Armuchee," is said to be responsible for encouraging a member of the U.S. Congress to acquire federal lands in the area and sold her own 1,200-acre tract on Taylors Ridge so that it could be included in the government holdings. (Courtesy of U.S. Forest Service, Armuchee Ranger District.)

Along the western brow of Rocky Face Mountain in Whitfield County are the numerous jagged boulders and limestone outcroppings that give the mountain its unusual yet fitting name. South of Dug Gap, where this photo was taken in 1940, Civil War trenches and breastwork remnants are still visible to the curious explorer. (Courtesy of U.S. Forest Service, Armuchee Ranger District.)

This 1940 photograph shows a U.S. Forest Service portel sign along Georgia Highway 136 near Maddox Gap on Taylor's Ridge when the highway was still a dirt road. When the road was later paved and widened, the stone base, which is an excellent example of Civilian Conservation Corps masonry, was partially buried. (Courtesy of U.S. Forest Service, Armuchee Ranger District.)

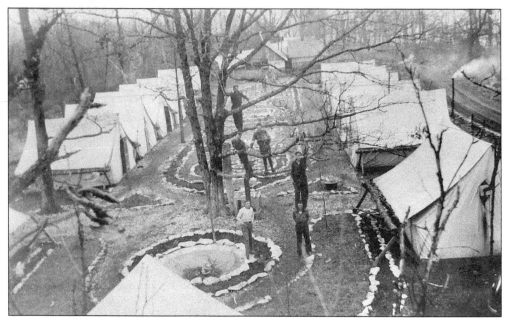

A Civilian Conservation Corps encampment is shown on Potato Mountain, Murray County, in the present-day Chattahoochee National Forest, sometime during the 1930s. Note the heated tents and decorative stonework. (Courtesy of Georgia Department of Archives and History.)

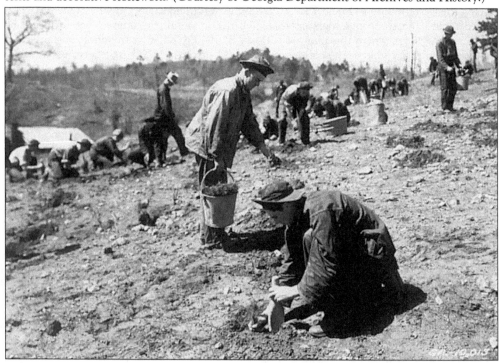

In burnt-over areas of the Armuchee Ranger District, loblolly pine seedlings were planted by CCC crews. The monthly wage of the young men was $30 and a substantial portion of that money was sent home to their parents. Today, the CCC is viewed as one of the most successful of the New Deal programs. (Courtesy of U.S. Forest Service, Armuchee Ranger District.)

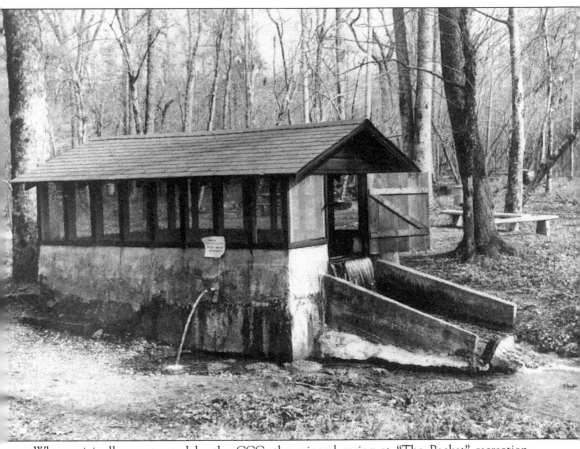

When originally constructed by the CCC, the mineral spring at "The Pocket" recreation area was fully covered to prevent debris from contaminating the water supply. Today the wooden and screen cover is no longer there, allowing children and adults alike to enjoy the immediate cooling effects of this artesian well. (Courtesy of U.S. Forest Service, Armuchee Ranger District.)

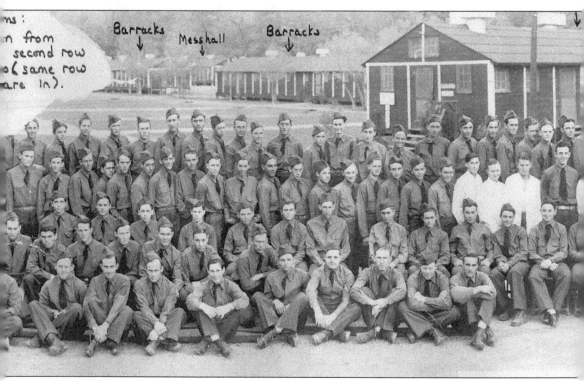

In 1933, 13 million people were unemployed in the United States. In response to this economic crisis, President Franklin Delano Roosevelt, only two days after his inauguration, created the Civilian Conservation Corps. His goal was to employ more than 500,000 youths in jobs related to forest, park, and range land conservation. The camps were run by the Army, but the U.S.

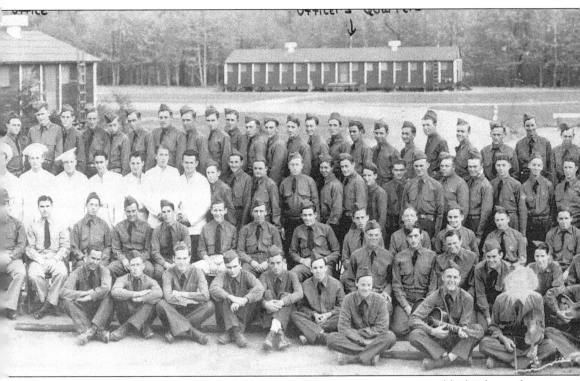

Department of the Interior and U.S. Department of Agriculture were responsible for the work projects of the young men. Three Civilian Conservation Corps camps operated in northwest Georgia, including this one at "The Pocket" Recreation Area: Company 3435, Camp Ga. F-16, LaFayette, Georgia. The photograph was taken on April 29, 1939.

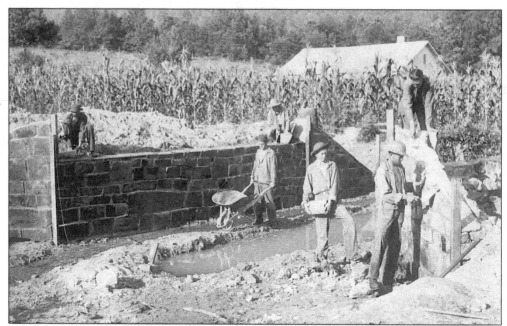

Young men in the CCC help build a stone bridge over a small stream near "The Pocket" in Floyd County. CCC enrollees were responsible for a number of duties during their tenure in this New Deal program, including fire protection and tree planting. This is a *c.* 1939 photograph. (Courtesy of U.S. Forest Service, Armuchee Ranger District.)

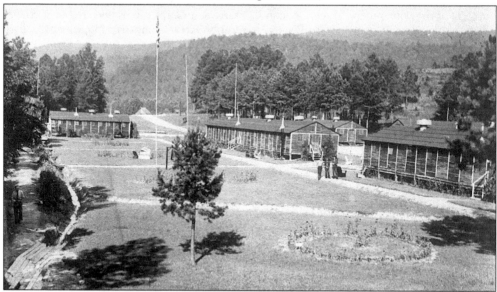

The Pocket Recreation area, as it is known today, was formerly the site of Civilian Conservation Camp F-16, which was in operation from 1938 to 1942. These are the main barracks for the enrollees, who were between the ages of 18 and 25 and were also unmarried. Most came from families on relief and each had the opportunity to re-enlist after every six months. Each enrollee was expected to work a 40-hour week and all were taught vocational work skills. The photograph was taken *c.* 1939. (Courtesy of U.S. Forest Service, Armuchee Ranger District.)

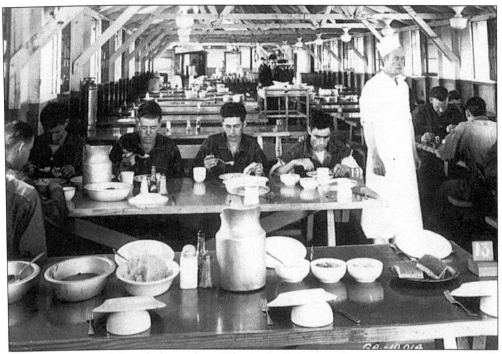

Enrollees eat one of their daily meals at "The Pocket" Civilian Conservation Camp mess hall. The young men worked long days planting trees, constructing towers, building roads, and connecting telephone lines within the Armuchee Ranger District. (Courtesy of U.S. Forest Service, Armuchee Ranger District.)

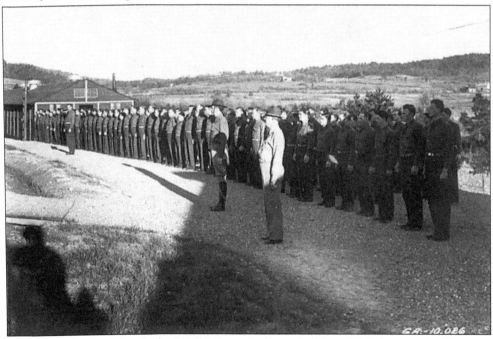

Morning roll call at "The Pocket" CCC Camp is shown in this c. 1939 photograph. (Courtesy of U.S. Forest Service, Armuchee Ranger District.)

Pictured here is the library in the educational building of "The Pocket" Civilian Conservation Corps Camp. Note the painted interior, hanging plants, globe, and magazines. (Courtesy of U.S. Forest Service, Armuchee Ranger District.)

This is the game room in "The Pocket" CCC Camp recreation hall. The sign at the canteen in the background reads: "Sales to CCC personnel only." (Courtesy of U.S. Forest Service, Armuchee Ranger District.)

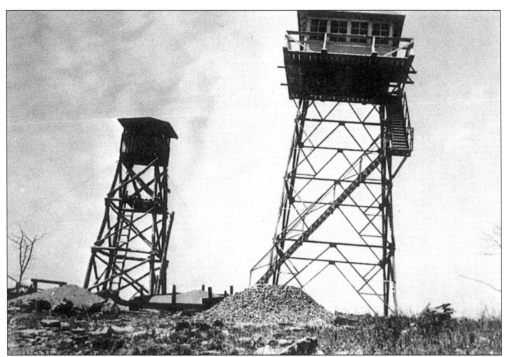

Fire towers like these, *c.* 1945, were essential to protecting the forest of northwest Georgia, as renegade fires could destroy hundreds of acres within a matter of days. According to former District Ranger Bill Black, the smallest of the two towers was originally constructed in the 1930s, with the aid of Civilian Conservation Corps labor. Its replacement was built in the early 1940s. (Courtesy of U.S. Forest Service, Cohutta Ranger District.)

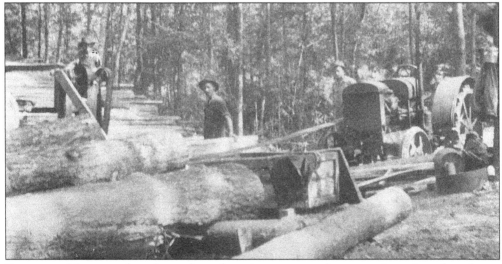

Forestry and forest products have always been important to the mountain region of northwest Georgia. Most farmers left a considerable amount of their land in timber and those trees often provided additional income during economic hard times. Many sawmills in the area were seasonally operated and moved from site to site by itinerant owners. This temporary bandmill operation was located on the farm of R. Lee Davis on Dawnville Road in Whitfield County during the summer of 1938. (Courtesy of Georgia Department of Archives and History.)

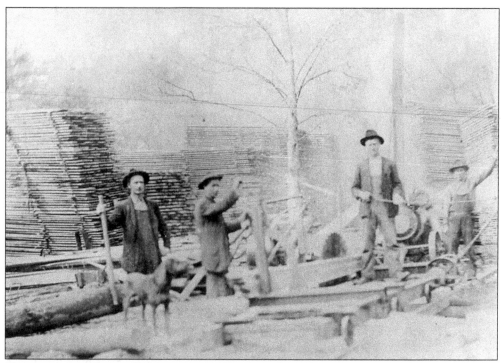

Shown is a typical sawmill operation, *c.* 1924, near the Cohutta mountains. (Courtesy of U.S. Forest Service, Cohutta Ranger District.)

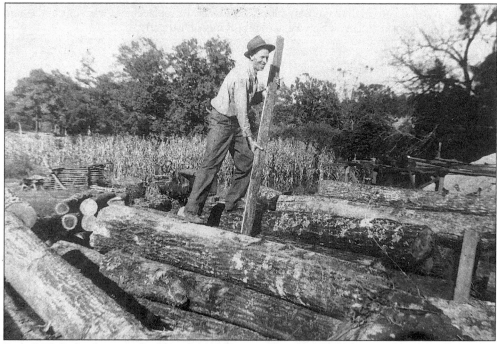

Russell Blalock, photographed here *c.* 1945, routinely transported logs to this sawmill, located south of Adairsville, Georgia, off Highway 140. Mr. Blalock used the lumber to build homes, which were then sold after construction. (Courtesy of Adam Fite.)

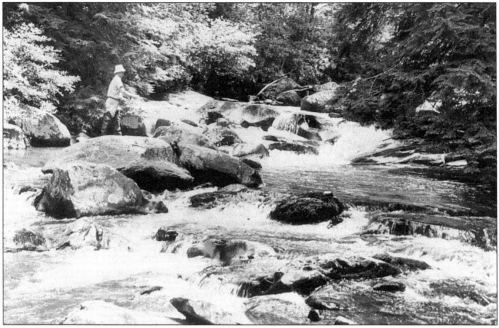

Trout fisherman fish on Jacks River, *c.* 1940, near Beech Bottoms, in what is today the Cohutta Wilderness Area. The Jacks River became a prime trout fishing area after non-native rainbow trout were stocked there in the 1890s. According to wildlife biologists, no trout, including Brook trout, could be found naturally reproducing in northwest Georgia mountains prior to the last century. (Courtesy of U.S. Forest Service, Cohutta Ranger District.)

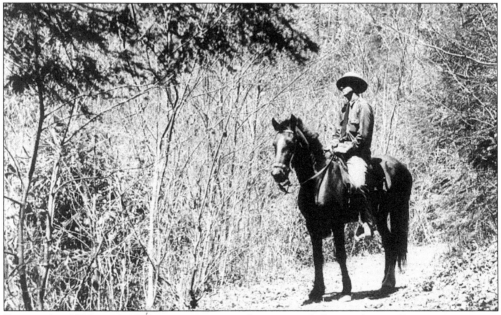

During the 1920s and 1930s, state game wardens roamed the northwest Georgia mountains checking fishing and hunting licenses from horseback. Pictured here is Hoyt Seabold, *c.* 1940, who patrolled the Cohutta Mountains of Murray and Fannin Counties during the 1930s and 1940s. (Courtesy of U.S. Forest Service, Cohutta Ranger District.)

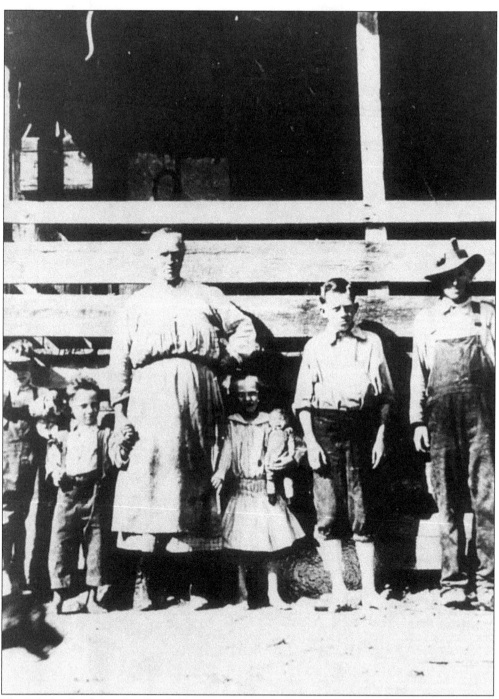

The Schuler family lived at Beech Bottom on the Jacks River and managed the cabin belonging to the Jacks River Hunt and Fish Club founded by Phil Stone and Lamar Westcott around 1930. Photographed here, *c.* 1935, from right to left, are George Schuler, Royster Schuler, Ester Schuler, Maggie Schuler, and two unknown individuals. As a boy, prominent Dalton physician Paul Bradley remembers seeing "leather-britches" or "shuck-beans" hanging from the front porch of this cabin. (Courtesy of U.S. Forest Service, Cohutta Ranger District).

Five

HIGH COTTON

Northwest Georgia has long been a region of small agricultural communities comprised of individuals with strong ties to the land. For the first half of the 19th century, both whites and Cherokees practiced small-scale mixed-farming agriculture, growing everything from wheat and oats to sweet potatoes and beans. Most farm families grew what they ate and made a great deal of what they wore. Many farmers in the region resisted large-scale, cash-crop agriculture, as transportation to outside markets was extremely poor. Very few plantations existed in the northwest Georgia mountains, but those that did, rivaled those of the Deep South in size and scale.

With the coming of the railroad to the region in 1847, an economic boom resulted. Dalton, in Whitfield County, temporarily became the economic center of the region and its depot became an important shipping point for more commercially minded farmers seeking to supply grains to seacoast plantations. As a result, wheat became a much more important crop in northwest Georgia, ranking second only to corn throughout much of the 1850s.

The Civil War devastated farms and farming in the Land of Ridge and Valley, sending it into an economic depression that would last for another half-decade. By the 1870s, with the return of important railroad lines, commercial agriculture was once again on the upswing. Fertilizer, in the form of commercial guano, also became readily available, which made the growing of cotton a much more profitable enterprise. By 1880, cotton production had more than doubled in the region, making towns like Dalton and Rome important collection points for the popular commodity.

Cotton growing became the lifeblood for many northwest Georgia residents and remained so through the Great Depression. In Bartow County, for example, 22,000 acres of cotton were under cultivation in 1879; by 1920, 55,000 acres of cotton were being grown. Most cotton lands yielded between one-half to one bale of cotton per acre, but these yields diminished after cotton was grown on the same fields year after year. Cotton growing had an important impact on native soils, which would eventually help undermine the region's potential as a major agricultural area.

With cotton fields came cotton mills. Industrialists in the post-war era believed that prosperity was hinged on manufacturing; cotton textile production was cheap and the raw material readily available. Among the first textile mill in the region was the Crown Cotton Mill, established in Dalton in 1885. It was undoubtedly the largest enterprise in the city and attracted labor from Whitfield County and surrounding communities. The Crown Cotton mill was neither the largest nor the first such establishment in the region, however, as the Trion Manufacturing Company was founded in 1847 in Chattooga County. By 1891, the Trion cotton mill was one of the largest in northwest Georgia. Outfitted with 22,000 spindles and 630 looms, it employed more than 500 individuals, including 300 young girls.

Initially, millwork did not appeal to local residents, especially the menfolk who were more content with farming as long as crops could be successfully harvested and annual debts paid. During the 1890s, more farmers in northwest Georgia were becoming less rather than more self-sufficient. Tenancy was also on the rise and poverty more widespread. For many, working for wages in a mill was seen as a necessity, brought on by increasing landlessness, fluctuating cotton prices, and debt peonage.

With the cotton mill came the cotton-mill village. After 1900, the typical cotton mill supplied modest homes for employees, which were leased to them for a percent of their wages. The mill village was almost always immediately adjacent the factory and had a unique character all its own. Although almost all the homes were of identical design, the employees were encouraged to take individual pride in their dwellings and were sometimes offered prizes for the best-kept yard and home.

In most mill villages, mill-hands were never fully severed from their rural roots and so brought the values of the countryside with him or her to the village. Some families even kept residences in the countryside and simply sent their children to work in the mills. Initially, the mill-village worker often continued to grow a vegetable garden, raise chickens, and pen hogs, and so the factory did not immediately destroy time-honored rural traditions. During the 1920s and 1930s, however, as more and more mill-village homes became electrified and furnished with indoor plumbing, mill villagers began to make clear distinctions between village folk and country folk, and many saw their country cousins as having a backward character.

By the mid-1940s, the mill-village was itself on the wane, although the textile industry was still vitally important to the area. The ability of workers to purchase their own homes, and the growing centrality of the automobile in people's lives, made mill-village life far less attractive.

By 1950, the cotton mill-village was all but obsolete in northwest Georgia. With the help of local investors and new technological innovations, carpet manufacturing began to replace traditional textile production in many northwest Georgia communities. Because synthetic fibers are largely used in the manufacturing of carpet, the importance of cotton production fell precipitously. Cotton, and the agriculture economy that supported it, was no longer king.

The rich alluvial soil of river bottoms have provided the area with some of the best farmland in the mountain region. According to government records, the amount of acreage in cultivated crops actually increased in northwest Georgia from 1910 to 1920, due in part to the added demand for food caused by WW I. This 1919 photograph is of the picturesque Alaculsey Valley below Iron Mountain, near the confluence of the Conasauga and Jacks Rivers in Murray County. (Courtesy of Georgia Department Archives and History.)

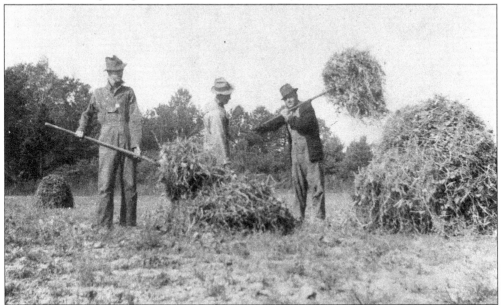

As cattle raising became more and more important to the local economy of northwest Georgia, the growing of hay also increased. Baling machines were uncommon until after WW II, so the most important tools of the harvest were a scythe, which was used to cut the crop, and a pitchfork, which was used to stack the hay into single shocks. (Courtesy of Georgia Department of Archives and History.)

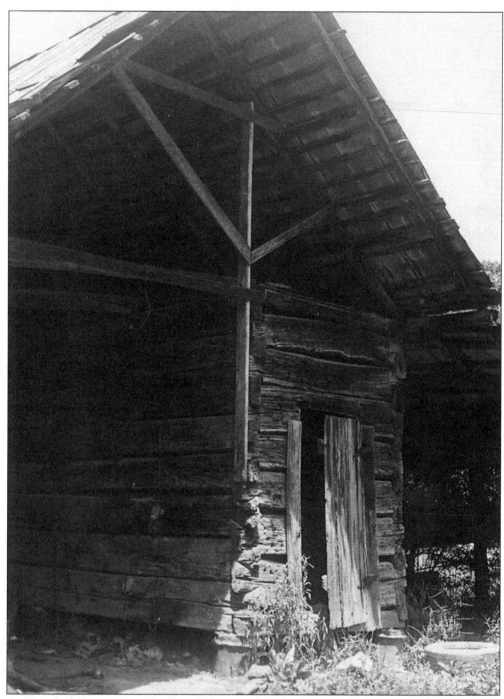

A uniquely designed corn crib allowed the corn to be loaded directly from the wagon or wagons, which could pass on either side of the central storage area. This "cantilevered" design is of German origin, although it was copied by many other ethnic groups in the mountains during the 19th and early 20th centuries. This corn crib was located on the Brackett Farm in Dawnville, in Whitfield County. (Courtesy of Whitfield-Murray Historical Society.)

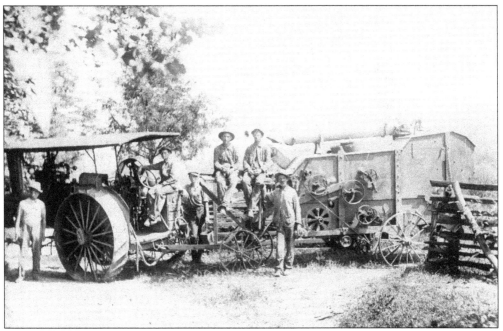

George and Floyd Messer, noted steam engine enthusiasts, also ran a wheat-threshing operation that annually toured northwest Georgia and southeast Tennessee. Floyd Messer built the engine seen here, as well as several others that operated in the area. Pictured, c. 1940, from left to right, are George Messer, Floyd Messer, three unknown threshers, and Dave Lane. (Courtesy of June Edmondson.)

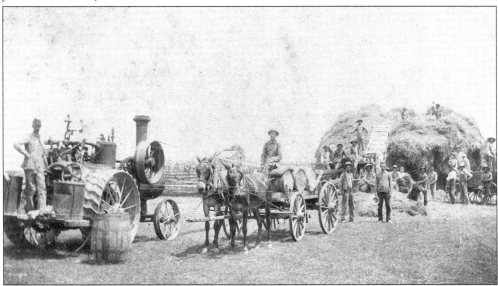

Wheat and wheat threshing was a much more common site on 19th-century and early-20th-century northwest Georgia farms. Threshing wheat by hand was an arduous and labor-intensive task that provided the incentive for itinerant wheat threshers to offer their services to local farmers. In this scene, a wagon carries barrels of gasoline, which runs the tractor's engine, which in turn propels the thresher. The photograph was taken on Morgan Valley Road near Rockmart in Bartow County, c. 1910. (Courtesy of Georgia Department of Archives and History.)

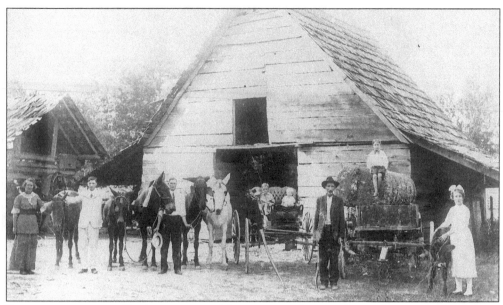

Rome was unquestionably the epicenter of the cotton trade in northwest Georgia; by 1880, more than 100,000 bales were annually traded at the river-port town. In 1938, there were 13 cotton merchants in Rome, most operating around the parcel of land known as the "Cotton Block." This 1910 photograph displays a single bale of cotton that probably brought the owners $40, the going price for ginned cotton at that time. (Courtesy of Georgia Department of Archives and History.)

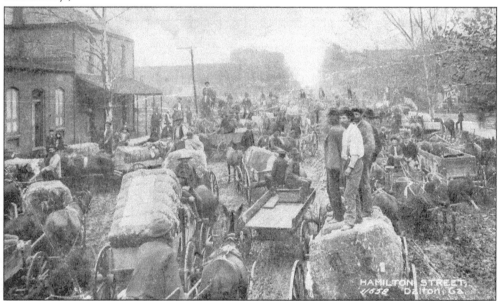

The hustle and bustle of northwest Georgia cotton markets is unmistakable in this 1900 photograph of a cotton auction on unpaved Hamilton Street in Dalton, Georgia. Only Rome's "Cotton Block" in Floyd County could rival the intensity of the trading seen here. Most of the bales were brought in by local sharecroppers who sought to make at least one-third of the total profit from the annual sale. When this photograph was taken, cotton was bringing around 20¢ per pound. (Courtesy of Georgia Department of Archives and History.)

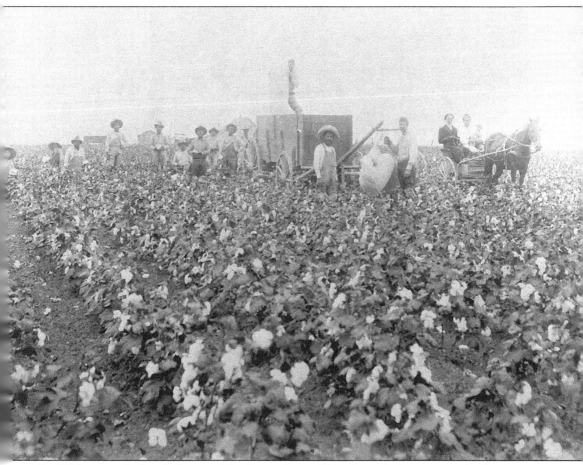

By 1890, cotton had truly become king in northwest Georgia, replacing corn as the dominant cash crop. By 1929, less than 20 percent of all farms in the region were planted in corn. Cotton production also encouraged tenancy as more than half of all farms in the area were operated by tenants after 1900—the highest rate in all southern Appalachia. Photographed here, c. 1912, is the Howard family and their neighbors picking cotton in a field near Smyrna Church, near Chatsworth. (Courtesy of Georgia Department of Archives and History.)

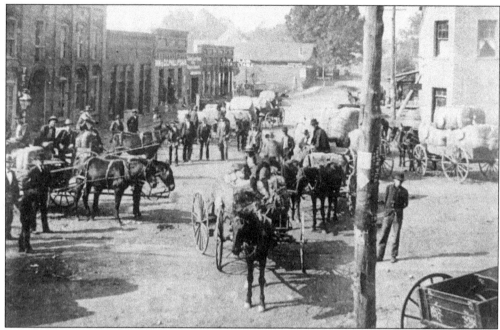

A *c.* 1905 photograph shows downtown Acworth, then a mere village on the border between Cobb and Bartow Counties. Like most towns in northwest Georgia, Acworth's cotton block was on the main thoroughfare, making it easier for farmers to bring their annual fall harvest. Note the wide, unpaved streets and numerous mule teams. (Courtesy of Bradley Putnam.)

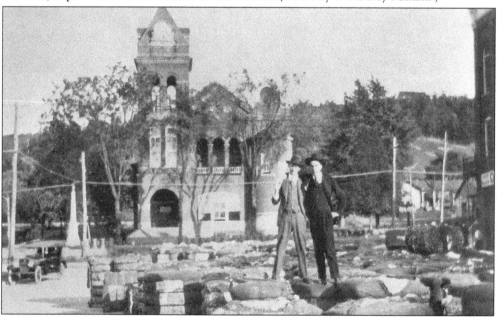

Tom Watts and Dan Lay stand atop bales of cotton in Calhoun's "cotton block" near Court Street in this *c.* 1919 photograph. A prominent member of the community, Lay was co-owner of Lay's ten-cent stores, which operated in three Southern states. In the background is the original Gordon County Courthouse, torn down in 1958. (Courtesy of Georgia Department of Archives and History.)

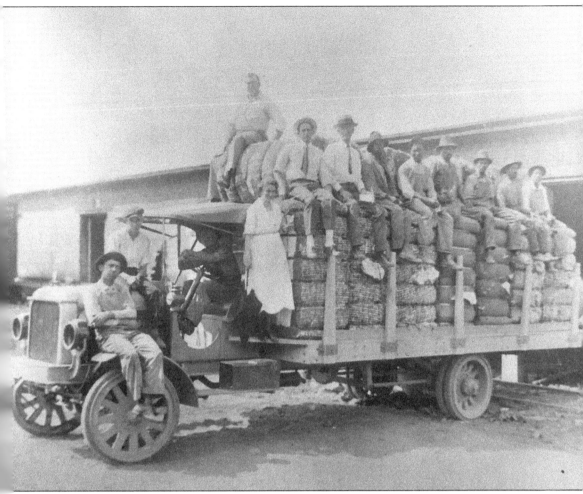

This historic 1918 photograph shows what is said to have been the first load of cotton shipped by truck to the Crown Cotton Mills in Dalton. The truck is parked in front of the Ingram Warehouse on King Street in Calhoun. Pictured here are Mark French, Carlton Brownlee, Lawrence Brownlee, Logan R. Pitts, and a number of unknown hired hands. (Courtesy of Georgia Department of Archives and History.)

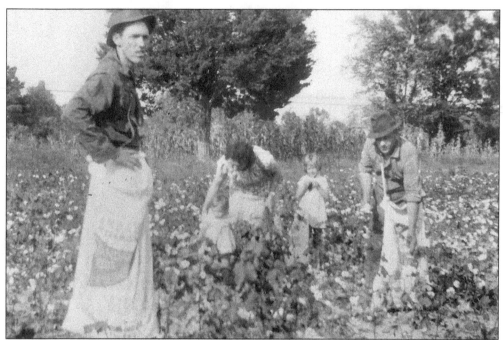

When the cotton crop was ready to be picked, usually in October, everyone helped in the annual fall ritual, including young children. In fact, many area schools allowed students to be absent from classes in order for this all-important task to be successfully completed. During the 1920s, workers for hire were paid 50¢ for each 100 pounds picked, but this wage fluctuated greatly during the decade of the Great Depression. This is a *c.* 1938 photograph. (Courtesy of Georgia Department of Archives and History.)

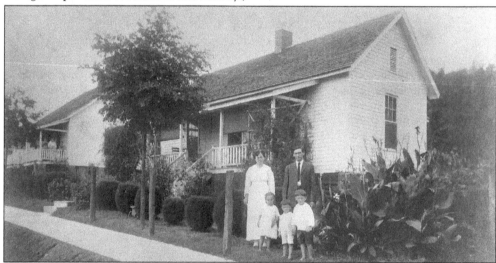

Textile mills in Dalton annually conducted contests to determine the most attractive home and yard, and this home along Chattanooga Avenue was one of the winners. Note the exceptionally large canna lilies, the topiary boxwood shrubs, and the hitching posts. Dalton, though industrialized earlier than most small towns in the South, retained its rural character for most of the first half of the 20th century. The photograph was taken *c.* 1919. (Courtesy of Georgia Department of Archives and History.)

By the 1930s, the candlewick and tufted bedspread industry of northwest Georgia was one of the most extensive employers of rural women in the Southeast. Historically, the home-craft had been practiced in many areas, including North Carolina, Kentucky, and Tennessee. A report published by the U.S. Department of Labor in 1935 clearly saw its economic potential to the region and asked for better coordination of the industry so as to benefit the women workers. Shown is a c. 1934 photograph. (Courtesy of Georgia Department of Archives and History.)

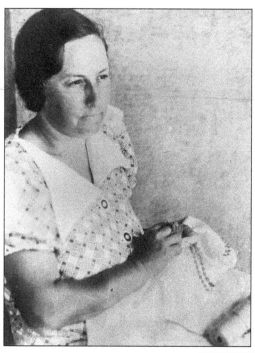

Ethel Partin hand "tufts" a bedspread during the 1930s, when this photograph was originally taken by Doris Ulman. (Courtesy of Dr. Tom Deaton.)

Folklorist Allen H. Eaton was one of the first national writers to spotlight northwest Georgia's candlewick bedspread industry in his classic work *Handicrafts of the Southern Highlands*, published in 1937. In it he wrote: "The most concentrated home industry and the one employing the largest number of workers in the Southern Highlands is the candlewick bedspread industry . . . The ride from Dalton through Calhoun to Cartersville, Georgia, is a most picturesque one with hundreds of bright tufted bedspreads flying from farmhouse clotheslines on both sides of the highway like banners of many colors." Here, Ethel Partin of Ringgold rubs a pattern on a swath of cotton fabric, one of the very first stages of the tufting process. This historic photograph was taken by Doris Ulman, one of the most celebrated photographers of the Depression era, c. 1934. (Courtesy of Georgia Department of Archives and History.)

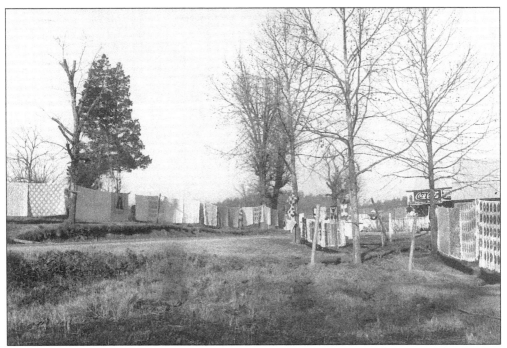

Shown *c.* 1937 is candlewick work displayed several miles south of Calhoun. Gordon County residents were among the most actively engaged in the candlewick bedspread industry. During the 1930s, according to county agent J. Cooper Morcock, 90 percent of the 2,000 families in the county were doing some type of bedspread work. (Courtesy of Georgia Department of Archives and History.)

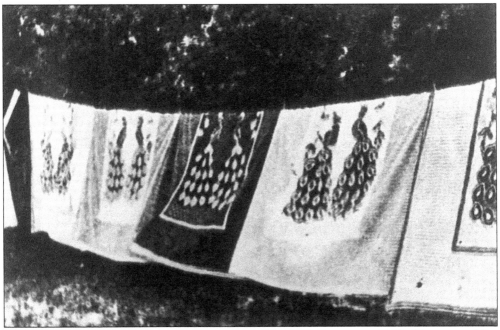

Peacock bedspreads hang along Highway 41 in Whitfield County, *c.* 1925. (Courtesy of Dr. Tom Deaton.)

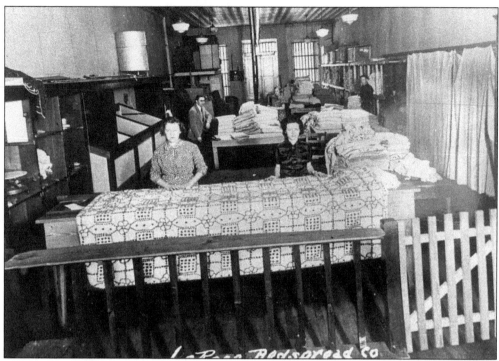

Shown is the spread sorting and folding room at the LaRose Bedspread Company in Dalton, Georgia, during the 1930s. (Courtesy of Dr. Tom Deaton.)

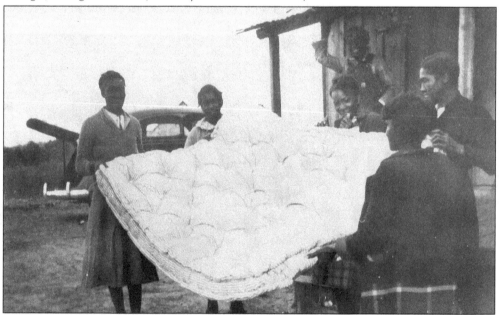

During the 1930s, the federal government gave 50 pounds of cotton and 10 yards of fabric ticking to enterprising individuals needing additional income. Home economist from the Farm Security Administration then taught these individuals how to make mattresses that could be sold locally. This photograph was taken in 1939 by Polk County home economist Zell Ryan Hemphill. (Courtesy of Georgia Department of Archives and History.)

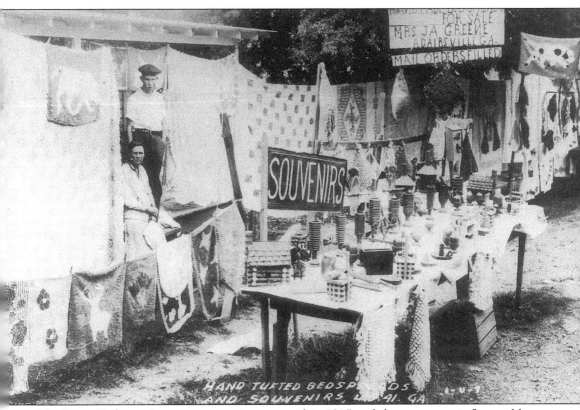

The Dixie Highway Association was incorporated in 1915 and the group was influenced by area business leaders who sought to connect northwest Georgia to the rest of the nation. By 1927, the route from Detroit to Miami was fully completed, making the road one of the most highly traveled in the United States. Along this popular thoroughfare sprung up motels, gas stations, and souvenir stands targeting motoring tourists. In northwest Georgia, roadside stands sold hand-tufted chenille bedspreads featuring colorful peacock designs. Soon, this section of the U.S. highway became known as "Peacock Alley" and the bedspread industry, with the help of local investors and new manufacturing techniques, later developed into the multi-million-dollar carpet industry. This photograph, taken in June 1940 in Bartow County, shows the handiwork of J.A. Greene of Adairsville. (Courtesy of Georgia Department of Archives and History.)

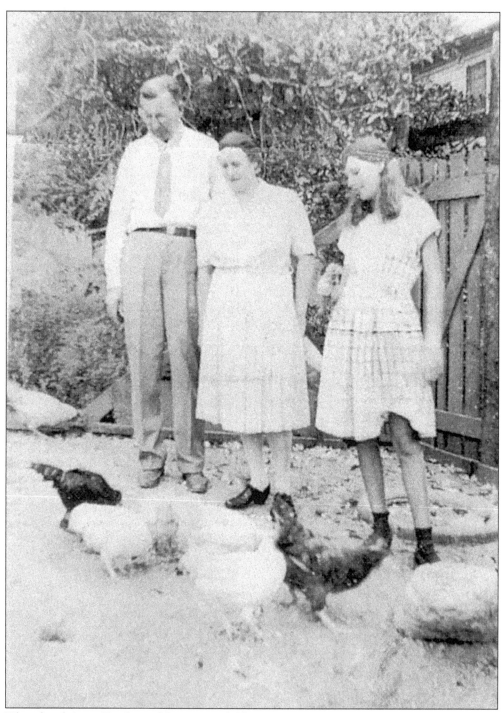

Edward and Anna Kioebge, of German and Alsatian ancestry, moved to Dalton, Georgia, from Chicago in 1942. The Kioebge's named their wholesaling business—Anita Textiles—after their youngest daughter Anita, who is also photographed here. Enamored by the rural beauty of the northwest Georgia mountains, the Kioebge's kept a small flock of laying hens behind their large Morris Avenue home. (Courtesy of Anita Davis.)

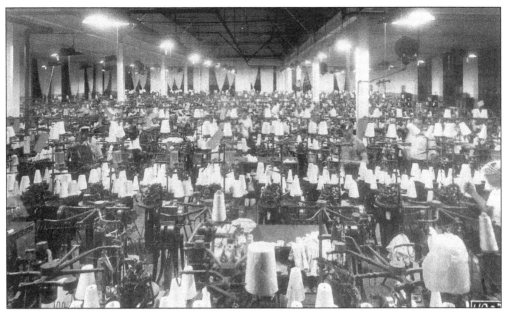

The interior of Westcott Hosiery Mills located on North Hamilton Street is shown in this *c.* 1930s photograph. G. Lamar Westcott established the business in 1917, and it operated there until the 1930s. Real Silk of Indianapolis bought the plant in 1928 and Lamar, his brother Fred, and Bob McCamy started a tufted bedspread company called Cabin Craft. (Courtesy of Georgia Department of Archives and History.)

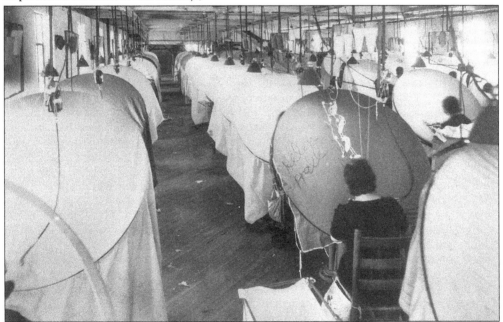

Shown is the interior of the needle-punch room for bedspreads, *c.* 1941, at the Cabin Craft Bedspread Company located on East Morris Street in Dalton. Each worker sat in front of a large embroidery hoop and dewed patterns stamped on the bedspread fabric. The tufted spread used in *Gone with the Wind* was a needle-punch product made at Cabin Craft. (Courtesy of Georgia Department of Archives and History.)

ACKNOWLEDGMENTS

Many people have assisted me in this project, including friends, family, and colleagues. Perhaps the biggest debt is owed to Dudd Dempsey, who helped scan the photographs and organize captions amid the chaos of my hectic teaching schedule. Her skill, expertise, and patience is without parallel and the book could have not been done without her. John Hutcheson is also owed much thanks for strongly encouraging me to contact Arcadia Publishing. Gail DeLoach of the Georgia Department of Archives and History was always courteous and professional in processing the numerous photograph acquisitions that make up a significant portion of the book. Brent Martin deserves a special note for introducing me to the state geologist photograph series housed in the Original Documents Reading Area (ODRA) of the Georgia State Archives. Katie White, at Arcadia Publishing, was enthusiastic about the project from the start and helped to shepherd the book into its present form.

I am also indebted to the members of the Dalton State College Foundation, who provided me with a semester leave in order to undergo the photograph collection phase of the project. Ann Treadwell is also to be commended for her vision and creative insight that allowed select photos in this book to become part of major exhibitions at the Creative Arts Guild in Dalton, Georgia, and Calhoun-Gordon Arts Center in Calhoun, Georgia. Ms. Treadwell was also helpful in assisting me in acquiring a grant from the Grassroots Arts Program of the Georgia Council for the Arts, whose monies helped to purchase many of the archival photographs. Tom Deaton is owed special thanks not only for his many comments on the role of cotton production in northwest Georgia, but also for lending an ear in a time of great need. Special thanks to Mike Edmondson for, as always, coming through in the end. And finally, thanks to my mother, Anita Kioebge Davis, whose very face adorns the pages of *The Land of Ridge and Valley*.

Printed in the USA
CPSIA information can be obtained
at www.ICGtesting.com
LVHW082325220923
759028LV00026B/33

9 781531 603779